Women, Work and Triumph

Other Works by Beverly Gandara

Screenplays

Rent Money
Comedy
Winner of the Golden Palm Award for Best Screenplay at the 2012
Beverly Hills International Film Festival.

Concrete Wings
Family Drama/Coming of Age

Misinformed Heart
Drama

Turnaround
Family Drama
Co-written with John Han.

Unprotected Witness
Drama/Thriller
Co-written with Jack Knight.

While I Wait
Drama

Novels

Concrete Wings*
Historical Fiction
Five Star Readers' Favorite. Literary Classics Seal of Approval with
recommendation for school and home libraries:
* Concrete Wings is inspired by a screenplay of the same name.

Soaring in Silence*
Women's Fiction
Five Star Readers' Favorite:
*Soaring in Silence is based on a screenplay titled Unprotected Witness,
co-written with Jack Knight.

Author's Note:

This manuscript is based on roughly seventy-five hours of written and recorded interviews with the twenty-six fascinating women featured in this book. Each talented woman has an interesting journey and a compelling story to tell. Except for editing for space, grammar and spelling, the stories in this book are told in their own words. Author's notes were added where I felt the need for the definition of technical terms and general facts of interest.

In the interest of full disclosure, three of the women in the spotlight are relatives; an aunt, a cousin and a niece. Three are dear friends and the others are acquaintances in the form of friend, neighbor, colleague, associate and contact for the purpose of this book.

ISBN: 978-0-9971406-5-1
Paper Back: 978-0-9971406-5-1
Author website **www.bevgandara.com**

Avivar Press, LLC
Myrtle Beach, South Carolina
www.avivarpressllc.com

Dedication

For Armand, simply the love of my life; I adore you. I am blessed by your unconditional love and forever grateful for your intelligence, grace, strength and beauty – inside and out.

To the loving memory of my parents, Irene and Stanley Kopelman, gone too soon.

Table of Contents

Acknowledgments

The people named below have all generously contributed their time and talent to the betterment of this book.

To my darling husband Armand for his support, love and wisdom in helping me compile and organize the work into a readable format.

With gratitude to the beautiful women named below, who agreed to share their personal stories by answering a questionnaire geared towards their work. Added to the questionnaire was a space titled MY WORDS; MY VOICE in which each woman was asked to encourage, share, suggest or vent about any subject they chose. Some supplemented their stories, added personal philosophy, shared wisdom gained from experience, suggested helpful links and/or advertised their website, business, products or services.

Bonnie Boland, Jeannie Gibson, Betsy Havens, Gina Hernandez, Linda Boston, Sharon Stallman Platt, Susan Reiss, Angela Mazzella, Honora Levin, Rosie Napravnik, Linda Vetrano, Sally Sasso, Rebecca L Kopelman, Esther Thambidurai, Diane Hofman-Seiple, Alexandra Rich, Susan Mathes, Helene Ferris, Brooke Guzar, Judith Swift, Dana Ridenour, Allison Ross, Anne Beatts, Bridgette Waters, Frances Miller and Tracy Lee Moller.

With respect and admiration for the elegant artwork of Hoi Yan Patrick Cheung, Ph.D. and his exquisite book cover design. http://unfoldingmoment.com/patrick-cheung

With deep gratitude to Ciara Cisneros, a highly skilled book designer for her sharp eyes and gentle guidance in readying the book for publication in all its formats.

With appreciation for Peter Zriokas' skilled editing, courtesy and professionalism.

Photo of Beverly Gandara by George Atoraya Simonov.

Photo of Bonnie Boland, NBC Publicity Department.

Screenshot Photos of Bonnie Boland, with permission from Johnny Dimsdale, Administrator of the https://verybradyblog.blogspot.com.

Photo of Linda Boston by Mark Trupiano Photography. www.trupianophoto.com

Album Cover Design for Linda Boston's "Permission," by Lititia White Moss of LT Graphics & Consulting, Inc. www.LTGraphicsonline.com

Photo of Rosie Napravnik by MagnaWave PEMF. www.magnawavepemf.com

Photo of Rosie Napravnik by Jim McCue/Maryland Jockey Club.

Photo of Rosie Napravnik by Samantha Clark. www.samanthaclarkphoto.com

Photo of Sally Sasso by Todd France Photography. www.toddfrancephoto.com

Photo of Alexandra Rich by Javier Caballero Photography. www.instagram.com/javiercaballerophotography

Photo of Helene Ferris by Geraldine Bien. https://www.facebook.com/GeraldineBienPhotography

Photo of Brooke Guzar by Michael Kaiser https://akaiserphoto.com/

Photo of Allison Ross by Amy Corman Photography. www.facebook.com/AmyCormanPhotography

Photo of Anne Beatts by Mikul Robins.

Photo of Anne Beatts with *Saturday Night Live* writers and cast members by Edie Baskin. Photograph Licensed by Edie Baskin Studios. All Rights Reserved. www.ediebaskin.com

With appreciation for their courtesy to me and respect for their employees:

Seth Greenleaf, CEO/President GFour Productions – *Menopause The Musical*

Mark Ingraham, Director of Events, Hoffman Media, LLC and Original Sewing & Quilt Expo. www.sewingexpo.com

Keith Fullerton, Chief Executive Officer, Ice Skating Queensland & Iceworld Olympic Ice Rinks, Brisbane, Australia.

x

Women, Work and Triumph

Interviews with Fascinating Women

By Beverly Gandara

Introduction

With thanks to the courageous women of the past who fought for independence, this book is dedicated to all the women of the world, our mothers, daughters, sisters, grandmothers, granddaughters, aunts, nieces, cousins, friends, colleagues and neighbors who may have struggled to be accepted and respected. It has been a challenge for women over the centuries to express their talent, intelligence and ability outside the home in professions, industries and fields dominated by men.

As we celebrate the one hundredth anniversary of the passage of the 19th Amendment to the U.S. Constitution which granted American women the right to vote on August 18, 1920, we are reminded that African American women were still held back in some states because of racial discrimination. It would take another forty-five years for that to be rectified thanks to civil rights activists Diane Nash, Fannie Lou Hamer and Ella Baker and others who continued to battle for voting rights for all, which resulted in the passage of the Voting Rights Act of 1965. If it weren't for Elizabeth Cady Stanton and Lucretia Mott, we wouldn't have had the first convention dedicated to women's rights in Seneca Falls New York in 1848, which was the start of the Women's Suffrage Movement.

In my lifetime, women have moved from traditional roles of wives, mothers, home makers, caregivers and dependents to independent women in executive positions in education, entertainment, finance, government, law, law enforcement, medicine, military, politics, religion, science, sports and technology and other male-dominated fields, professions and jobs. While significant progress has been made thanks to the continued fight for equality by the Women's Liberation Movement of the 1960s and 1970s led by Betty Friedan, Gloria Steinem, Bella Abzug, Shirley Chisholm and others, it's been my experience that change comes slowly.

Sadly, according to the U.S. Department of Labor statistics, there

is still a gender pay gap. While women make up approximately 50% of the population, in the current 116th United States Congress women occupy only 101 (23.2%) of the 435 seats in the House of Representatives and twenty-six (26%) of the one hundred seats in the Senate.

My hope is that women continue moving from strength to strength and claim their rightful place as they wish without judgment, restriction or challenge.

To interview the twenty-six fascinating women I looked to family first and the women I knew for inspiration. I have one aunt who continues to inspire by her love of family and joyful energy for life, a cousin of whom I am very proud who rose to executive status in a male dominated industry, and a niece who put aside her career as a scientist and fully embraced motherhood to raise her two children. I included three life-long friends and others I've met through work or social situations. In addition, I interviewed women I have yet to meet but whose work I admire. Sharing their courage and sensibility, all of the women interviewed for this book have been successful. Success isn't always measured by what one becomes, but often what one overcomes.

Here are their inspiring stories.

Bonnie as Myrna Carter
The Brady Bunch.

Bonnie as Mabel
the Mailperson
Chico and the Man.

Screenshot Photos of Bonnie
Boland, with permission
from Johnny Dimsdale,
Adminitrator of the
www.verybradyblog.
blogspot.com

A is for *Actress*

Bonnie Boland

Bonnie was active 1968-1975 as an actress in television, film and theater and was privileged to work with icons of the era like Lucille Ball, Tim Conway, Sammy Davis, Jr. Henry Fonda and Jimmy Stewart.

After receiving her associate degree from Queens College in New York, Bonnie went out into the world to work without a clue as to what she wanted to do. Being the creative type, she knew she did not want a 9-5 job; there weren't many options open to her.

By a chance meeting with an entrepreneur in the office where her mother worked, Bonnie was referred to a modeling agency whose new focus was on character types or as the trend was growing "real people" while moving away from the curvy, glamour types. Bonnie's 5'9" slender frame represented that look to them, and she was hired on the spot.

Successful in print ads, she easily moved to television commercials and with several commercials running, relocated to Hollywood to pursue her acting career. Her success continued as she was a frequent guest on episodic comedy shows and specials. Unfortunately, her portfolio was stolen. It contained photos of all her modeling and acting assignments. For more information about Bonnie's acting career, visit the Internet Movie Data Base (IMDb) **www.imdb.com/name/nm0092657**.

After marriage and children, she left show business to focus on her family.

I met Bonnie in Manhattan when we were both on the verge of womanhood. She a young model on the way to a successful career, me a bookkeeper/secretary working my way up through the corporate structure.

I worked for two lovable, highly energetic young men in the radio and TV barter business who split the rent with a fast talking event promoter. Bonnie's mom was his secretary and she and I shared a dingy, cramped office in the heart of the theater district.

Daily, Bonnie walked to "go sees" (possible modeling jobs) and model shoots. In between appointments, she came to the office to use the phone and write thank you notes to all with whom she communicated whether she got the job or not. Her mom's boss charged her a quarter for every three calls she made.

We became close friends and to this day share all of our challenges and triumphs. Bonnie and I live on opposite coasts. She recently sent this simple note:

"Dear Bev: I think of you every day and wish we lived around the corner from each other. I treasure your friendship. Love, Bon"

I feel the same. Give your girlfriends and anyone you love a hug. That human touch cannot be duplicated over the phone or in an email no matter how many emojis you include. How I miss just catching up over a cup of coffee.

Here are her answers to the questions:

Where were you born?
New York City at Women's Hospital.

How would you describe your childhood environment?
Middle class, urban.

As a child, what did you hope to be when you grew up?
I wanted to be a teacher.

Did you know as a child that you would be engaged in your chosen work?
I did not know that I would become a model and pursue acting.

Would you like to acknowledge one or more individuals who helped you shape your behavior, beliefs and work habits while on your early journey?
The person to whom I am most indebted to is "Staigee" (Mrs. Marie Steiger, the neighborhood babysitter.) She was kind, patient and understanding. I adored her.

As a young girl what difficulties did you have to overcome to move towards your dreams?
As a young girl, the difficulties I faced were the feelings that I was not attractive and I feared relationships and the opposite sex.

Where were you educated/trained for your work?
I was not really trained for modeling or acting. That all happened as on
the job training. I attended Queens College and received my Associate
of Arts degree before I went to work. One of my earliest jobs was
helping to distribute *Backstage*, a theatrical publication to newsstands
in Manhattan.

How much training did your work require?
On a visit to my mother's office, I met Harry Hornick who advised me
that the modeling industry was moving away from "gorgeous people"
and leaning more towards character types, which he emphasized as
"real people." He concluded that my 5'9" slender frame was perfect for
the new trend and referred me to the Cy Perkins Agency. They signed
me immediately and I worked steadily as a print ad model, which
included a two page spread in a national magazine for a mattress
company. Television commercials followed and while I didn't train as
an actress, I took lessons in voice projection, singing, and tap dancing.
The scripts were easy to memorize and I found the work pleasant.

In the late '60s I met Jack Knight, an up and coming actor at the *Improv
Club* who left a lasting impression in my mind. My modeling career
blossomed and with several television commercials running, I relocated
to Hollywood to pursue acting.

I signed with the William Morris Agency and had a successful career
in episodic television with appearances in *Julia, The Beverly Hillbillies,
I Dream of Jeannie, The Jimmy Stewart Show, The Tim Conway Comedy
Hour, Love American Style, The Brady Bunch* and *Chico and the Man.* They
were all popular shows, particularly *The Brady Bunch* which was about
a large blended family and *Chico and the Man* which was about the
developing relationship between an upbeat young Mexican American
and a cranky old man who runs a failing garage in East L.A.

**Once you entered the workplace, as a young woman, what obstacles
did you have to overcome?**
My own insecurities.

As a woman, what challenges did you have to overcome?
My own insecurities and fear of fame. I just wanted to do the work and
go home to a quiet life.

While in Hollywood, I saw a television commercial featuring Jack Knight and sent him a note. He visited me in Hollywood; we fell in love and married in 1972. We both worked steadily in television and the movies and in 1973, our first child was born.

In the 1974-5 season I played Mabel the Mailperson on *Chico and the Man* opposite Jack Albertson and Freddie Prinze. The show was a hit and I was gaining recognition and a lot of attention from strangers. Fame frightened me. During that time, I became pregnant with my second child and made the decision to focus on family and raise my sons. I left my acting career and never regretted the decision.

Are you satisfied with your chosen profession?
Yes. As the boys grew up, I took a job as a teacher's assistant in the L.A. County School System, which I thoroughly enjoyed for over twenty years. I enjoyed both careers and was confident I did a good job in each.

Describe a typical work-day from morning 'till night.
My typical work-day as a model/actress was to arise early, know my lines, my marks and smile. I read the entertainment-related bulletins and newspapers and in between jobs, I attended auditions. I kept records of whom I saw or called and developed and maintained relationships with agents, producers and other actors. I always followed up after every meeting by mail and telephone.

As a teacher's aide, I arrived early, helped the children get ready for their classes and followed the teacher's lead throughout the day, working with the children who needed assistance.

Are you preparing for a different career?
I am not preparing for another career.

Have you continued your studies?
I have not continued my studies, but I do keep up with current events.

What are your current goals?
My current goals are to rest and play and spend more time with my family.

Do you have a ten year plan?
I do not have a ten year plan.

Where do you see yourself living in ten years?
California, as long as my family is here.

Do you have a twenty year plan?
I do not have a twenty year plan.

Do you have a retirement plan?
I am retired.

How do you spend your leisure time?
Sewing, reading and doing artwork projects.

What frightens you?
Life in general.

What saddens you?
People smoking; present day politics.

What pleases you?
I am pleased when I spend time with my boys.

What advice would you give your younger self?
Be open to opportunities and be willing to consider all options.

What advice would you give a young woman entering your field?
I would advise a young woman entering the entertainment business to be aware of the struggles she'll be facing like rejection and unwanted sexual advances. There will be long periods of down time between jobs. I would suggest she work constantly to hone her craft. I would urge her to learn the new technology associated with self-promotion.

MY WORDS; MY VOICE
I love children and am saddened by what they are exposed to in the form of games, lyrics, movies and television programs that include foul language and violence. I am sad that manners and respect are not taught in the home as it was when I gew up. Children are resilient and smart and I hope will make the world a better place.

I am disappointed in our political system and would hope that we temper the anger and come back to a place where we are united and

proud to be Americans whatever our nationality.

I am disheartened that our environment has been damaged and hope that we pay attention to our surroundings and take better care of our earth.

We all deserve to be the best we can be and enjoy a good quality of life in safety while we journey through our lives. My hope is that we know our history and learn from the past.

B is for
reast Health Navigator

Jeannie Gibson

Jeannie's career has been dedicated to health promotion and oncology work. The last three and one half years she has worked as a Breast Health Navigator where she assists patients through each step of the screening and diagnostic process for breast health and cancer detection. She has also worked with various programs at the American Cancer Society for breast, cervical and colorectal cancer screening.

Her passion to help others through a cancer diagnosis began when she helped care for her father who had pancreatic cancer.

Jeannie received her bachelors' degree from Coastal Carolina University. She lives in South Carolina with her loving husband and two beautiful daughters. They're a close family and love everything about the beach where they spend a lot of time!

Upon meeting Jeannie, I was immediately impressed by her personal warmth and professional knowledge. I am delighted that she agreed to participate in this book and appreciate her sharing her valuable time as she deftly juggles her challenging career while she and her husband raise their two young daughters.

Here are her answers to the questions:

Where were you born?
I was born in Canton, Ohio.

How would you describe your childhood environment?
My childhood was great growing up in a small town with terrific family and friends, many with whom I am still close and greatly miss. I was active, engaged in sports, gymnastics, cheer, and track.

We spent summer vacations in Florida and that is where I fell in love with the beach.

As a child, what did you hope to be when you grew up?
As a child, I hoped to be a marine biologist.

Did you know as a child that you would be engaged in your chosen work?
I had no idea I would be engaged in my current work.

**Would you like to acknowledge one or more individuals who helped you shape your behavior, beliefs and work habits while on your
early journey?**
The people who helped me on my early journey are my supportive parents and husband. My parents instilled a good work ethic. My husband wants me to be happy and encourages me to follow my heart. He understood when I quit my job to care for my dad as we struggled through his battle with pancreatic cancer.

As a young girl what difficulties did you have to overcome to move towards your dreams?
As a young girl, the difficulty I faced was the move away from home from Ohio to South Carolina. But I ended up loving it.

Where were you educated/trained for your work?
I was educated at Coastal Carolina University, The American Cancer Society and the Best Chance Network Program.

How much training did your work require?
Mostly on the job training.

Once you entered the workplace, as a young woman, what obstacles did you have to overcome?
As a young woman, once I entered the workplace, initially in sales, I had to develop self-confidence to deal with competition. I was in the field for a long time. I learned it was important to develop relationships and an understanding of others' responsibilities in order to gain respect and rapport.

At my current job, my biggest obstacle is trying to make everyone happy. As a liaison between multiple departments and between patients and providers, often what works well for one person or department creates push back or delays for another person or

department – so trying to figure out what is best overall can be difficult. Additionally, overwhelming workloads require constant prioritizing skills. It is a challenge.

As a woman, what challenges did you have to overcome?
As a woman, the challenge is balancing the demands of being a good wife and mother with the obligations of work. It's hard to turn my work "off" when I go home; I care constantly about all my patients.

Are you satisfied with your chosen profession?
I am very satisfied with my work. I feel I am in a position where I truly help people and make a scary time a little easier to deal with.

Describe a typical work-day from morning 'till night.
My typical workday varies. I basically try my best to assist patients, doctors and department staff with whatever comes our way that day. There are call backs, orders, patient support, patient and doctor communication and administrative meetings with a focus on program improvement to ensure patients have a compete continuum of care.

Are you preparing for a different career?
I am not preparing for a different career.

Have you continued your studies?
I continue my studies through general ongoing topic education.

What are your current goals?
My current goal is to become a certified navigator (NCBC) and help our mobile mammogram program grow. I currently qualify patients for grants. Our Foundation applies for grants and donations and I help them by answering questions/making suggestions/bringing up questions/concerns/solutions. While I am more on the patient side and provide general support for the Foundation, I want to continue to find, secure and support our hospital to help more and more patients.

Author's Note:
After her program received a sizeable donation, Jeannie was interviewed on a local news program; she represented the program well.

Do you have a ten year plan?
My ten year plan is to focus on my children's development.

Where do you see yourself living in ten years?
I see myself living in South Carolina.

Do you have a twenty year plan?
My twenty year plan is to spend my time with my husband traveling. We were together eleven years before the children arrived and did everything together.

Do you have a retirement plan?
My retirement plan is to continue traveling and cycling with my husband.

How do you spend your leisure time?
My leisure time is spent with my family; my husband and children who are my world. We spend as much time at the beach as we can, visiting with friends, indulging in kids' activities.

What frightens you?
What frightens me? Cancer, losing loved ones or if it were me.

What saddens you?
The thought of dealing with a diagnosis and treatment while raising kids and not being there for them. I don't want to miss out on anything.

What pleases you?
Being with family, being at the beach, summer days.

What advice would you give your younger self?
The advice I'd give my younger self is to find a job that makes me happy and create a balance between work life and home life.

What advice would you give a young woman entering your field?
My advice to a young woman entering my field is to have compassion and enthusiasm to help others and you will find a way to make the rest of your role successful.

MY WORDS; MY VOICE

The reason I went into the Cancer field was because of my dad and our experience with the Cancer Treatment Centers of America. That led me to The American Cancer Society and The Best Chance Network Program.

"Going Downtown"

"Wisdom of Joy"

C is for *Creative Artist*

Betsy Havens

As a creative artist, Betsy's love of the human figure in painting has led her to subject matter of the street scene, the café, markets, fishermen, dancers, historical figures and portraits of contemporary Americans.

She began her studies at age twelve at the Telfair Museum of Art in Savannah, Georgia and studied art throughout her school career. Educated at the University of Georgia and the University of South Carolina, she earned a Bachelor of Arts in Design and did postgraduate work in the History of Architecture and Southern Literature.

Betsy has received many awards for her work which is collected widely by private and corporate collectors such as.

- First Citizens Bank Permanent Collection, Columbia, South Carolina

- Colonial Life Insurance Headquarters, Columbia, South Carolina

- Themis Fine Arts Permanent Collection, Columbia, South Carolina

- Franklin G Burroughs-Simeon B Chapin Art Museum, Myrtle Beach, South Carolina

Shows:

- Columbia College Show - 9 Creative Couples from South and North Carolina

- Rice Museum, Georgetown, South Carolina

- National Steeplechase Museum Show, Camden, South Carolina

- Franklin G Burroughs-Simeon B Chapin Art Museum, Myrtle Beach, South Carolina

Betsy's travels throughout the world give her great inspiration for her paintings of the people, the land, and the architecture. She paints her own interpretation of medieval and renaissance knights of Europe, domes of Byzantium, and landscapes of Tuscany and southern France. Married to artist James E. Calk, Betsy lives in South Carolina.

*My husband, Armand and I met Betsy and her husband, James Calk, also
a prominent artist at the Franklin G. Burroughs-Simeon B. Chapin Art
Museum in South Carolina during a joint exhibition of their paintings. We
were immediately drawn to their warmth and sense of fun and look forward
to many years of continued friendship.*

Here are her answers to the questions:

Where were you born?
Bristol, Virginia.

How would you describe your childhood environment?
It was a neat and proper upbringing with a structured and creative
background. My parents grew up in Bristol, Virginia, were very
social, had many friends and attended tea dances, and such. My mom
was petite and lovely, dad was handsome. He was a paratrooper,
a lieutenant with the 82nd airborne in WWII and jumped into
Normandy the night before D-Day. I was twenty-one months old
before he returned home from the war. He loved music, great music,
classical music. He was a voracious reader. I have all his books about
the European Theater, WWII and other subjects. He was a
successful entrepreneur.

My grandparents lived next door, my grandmother grew roses and
brought bouquets to church on Sunday; my grandfather was always
outside happily greeting me, the neighbors and passersby. He made
me feel important.

I am the oldest of four children; I have three younger brothers. We
were all educated in art and music. One owned a gallery; one was
a forestry major, one was an art major. We had lots of fine art prints
and paintings on our walls and in each of our rooms. My brothers
had Van Goghs over their beds; I had Degas over mine. My younger
and middle brothers are creative artists. All three of my brothers have
sizeable art collections. We all know about art framing and archival
restoration. Over the years, the family owned fifteen frame shops.

We all took music lessons from the age of eight. Either we were taken to lessons or at one point a teacher came to our house and taught us instruments, piano, drums, harmonica. Every half hour one of us marched into the living room and took a lesson.

My parents' best friends were a brother and sister. He was a lawyer; she was an architect influenced by Bauhaus architects who fled Germany. She built us a Bauhaus-style home which combines fine art, craftsmanship and technology. So, in 1946-7 we had sliding glass doors, tile floors, parsons' tables, stools with red vinyl seats and tubular chrome legs and base at the rectangular folding dinner table and a red front door.

We had a fantastic huge two-toned green Buick with electric windows. It was great fun!

As a child, what did you hope to be when you grew up?
I can't ever remember thinking I wanted to be anything in particular. My dad gave me great confidence and encouraged me, so I knew I would succeed at whatever I tried.

Did you know as a child that you would be engaged in your chosen work?
No. But surrounded by brothers and my dad, I had so much fun with the boys, I would tell my mother, "I want to go with the boys." I was not afraid to compete with anybody.

Would you like to acknowledge one or more individuals who helped you shape your behavior, beliefs and work habits while on your early journey?
My parents and grandparents. My dad was always my best friend and it is from him that I received the bulk of my encouragement to achieve whatever I set out to do. I had great teachers in Virginia. When I was nine, we moved to Savannah, Georgia where I also had exceptional teachers; they were strong influencers. Mrs. Hackney, my piano teacher taught me about theory and music on her grand piano. She had been a close friend of Juliette Gordon Low, who was the founder of the

American Girl Scouts* (See Author's Note below.) I was a guide at her birthplace home where tours are still conducted to this day.

Author's Note:

Juliette Gordon Low's Greek Revival style birthplace home is Savannah's first registered historic landmark and the site where the first Girl Scout meeting was held March 12, 1912. According to Girl Scouts of the USA website, girlscouts.org "Timeline: Girl Scouts in History," <https://www. girlscouts.org/en/about-girl-scouts/our-history/timeline.html, it included 18 girls from influential families, the Female Orphan Asylum and Congregation Mickve Israel.

Recognizing the need for participation for all girls, in 1917 the troops for African American and disabled girls was established. In 1921 Native American Girl Scout troops formed on the Onondaga Reservation in New York State. In 1922 Latina troops were established in Houston. In 1925, Lone Troops on Foreign Soil (later called USA Girl Scouts Overseas) registered its first troop in Shanghai, China, with eighteen girls. In the 1940s troops supported Japanese American girls in internment camps. In the 1950s, The Girl Scouts fully integrated all of its troops. By 2012 the first transgendered girl was accepted in Denver, Colorado.

As a young girl what difficulties did you have to overcome to move towards your dreams?

Not much. None really because I was raised to believe I could accomplish whatever I set my mind to and not to worry about anything, just do it. So, I ignored what other people might consider difficulties and just pushed ahead!

Where were you educated/trained for your work?

The fortunate part was my parents recognized that I loved the arts, the fine arts, drawing and painting. So, at ages eleven and twelve I studied at the Savannah Telfair Museum of Art academy. Downstairs in the basement after school in the afternoon, I drew from life with live models, while my brothers played baseball. I was thrilled to draw. My mother encouraged me. I studied painting and drawing

all through school and attended the University of Georgia and the University of South Carolina where I earned my Bachelor of Arts in Design and did postgraduate work in the History of Architecture and Southern Literature. I tried to study business but went right back into art.

How much training did your work require?
Training is ongoing. Learning is a beautiful never ending process that thrills me. Taking workshops through the years was part of my growth and studying the history of architecture at the master's level was exciting. In school at the University of South Carolina, I was a big reader of art history. To me studying the fine arts painters throughout history is an essential component of being a great painter.

Once you entered the workplace, as a young woman, what obstacles did you have to overcome?
There weren't many female painters in the arts in the mid-twentieth century. Unless I wanted to leave South Carolina, and go to New York, I felt I wasn't going to succeed as a painter and knew it was going to be a hard, hard road, so I decided to stay where I was and paint and draw at night. I had to earn a living.

I was eager to go out into the big world, so I went with a girlfriend to Atlanta. In the late '60s early '70s there weren't many jobs for women other than teaching, which I refused to do. So, after a year of taking odd jobs when I couldn't find any work that was satisfying, my father said, "Betsy, why don't you come home, and we will open an art gallery." "Daddy, I'll be right there as quick as I can." He and I and one of my brothers opened a gallery and frame shops. My dad said, "Just do whatever it is you want to do. You don't have to worry about being a woman."

I eventually opened my own store which was further afield. It was a huge emporium with over 7,500 square feet filled with items from Tiffany, Cartier, Royal Dalton, Lalique, Rosenthal, Scandinavian Crystal, Baccarat and Cuisinart products. I traveled back and forth to

New York and my business grew to be quite large. I was the president and major stockholder. It was very successful and as it grew, I felt I needed training. I read *Minding the Store* by Stanley Marcus of Neiman Marcus. I contacted Mr. Marcus and asked to work for free at their headquarters just to learn the business. He suggested I go to Atlanta to work and learn. I wanted to work at their headquarters, so I wrote to him again.

Soon after that I was at a dinner party hosted by Allen Marshall, an architect, who designed the jewelry department in my store. I was the dinner partner to renowned architect Philip Johnson, who designed some of the most famous structures such as The Glass House in New Canaan, Connecticut The Crystal Cathedral in Dallas, the Seagram Building, the Lipstick building, the AT&T Building and the David H. Koch Theater in Manhattan. With my knowledge of art and architecture, we had a wonderful time. I invited him to my store thinking he would be interested in the building structure. Allen brought Philip to my store the next day. He was impressed, remarking "You didn't tell me about the store, just the building." As he walked around the store, he noted that I had German gourmet clay cooking pot boxes stacked on a railway station cart near a fine art sculpture stand with one of the pots sitting on top. With a grand sweeping gesture, he exclaimed "What ridiculous contradictions – and they work!" It was a high compliment coming from someone of his ilk.

I told him about my contacting Stanley Marcus. He informed me Mr. Marcus was a close personal friend of his. He contacted Stanley Marcus on my behalf, and I went to Dallas for the summer, worked in all departments, learned a lot, returned home and instituted what I learned. It's all about the teaching. They taught me well. I still have the letter Stanley Marcus wrote to me.

As a woman, what challenges did you have to overcome?
Not being taken seriously as a business owner. There were plenty of incidents that I ignored and followed my father's advice to just go on.

When I had my store, I needed a male to co-sign for me to have a credit card. (With the passage of the Equal Credit Opportunity Act in 1974, single and married women finally earned the right to get a credit card in their own names.)

The worst incident was not being taken seriously as a woman entrepreneur by another woman, a bank officer. After I sold my business and went into wholesale in Atlanta as a rep for Rosenthal, Dansk and Cuisinart, I needed a new credit card and went to the bank to apply for one; that's how it was done then. The female bank officer asked me what I earned and after I told her, she refused to believe me saying "You couldn't possibly earn that kind of money," and delayed the process. The following week I was at a gift show in Atlanta and the wife of the business owner for whom I worked as a product rep asked me who the woman in the bank in Columbia was. She called to check on my salary and my boss told her I earned way more than I stated. So, it was a woman who stood in my way.

In my opinion, men have gotten a bad rap. I don't have the feeling that I never got treated fairly by men – they were too friendly at times, and needed to be put in their place, but were never out of line and didn't prevent me from working. We had a hierarchy then. A woman could be secretary but never president. That's how it was but I did it anyway.

Are you satisfied with your chosen profession?
Yes. I enjoy art and everything associated with it. As a business-woman and an artist, I appreciate my business ventures and now thoroughly savor my ability to paint full time.

And through all those years, I did both.

After my father retired, I ran his businesses for over twenty years, but always drew and painted at night.

One of my father's businesses was as a dealer for Baldwin Pianos and Organs. Whenever he needed an instrument demonstrated, he called on James Calk, a concert trained musician and painter. That's how I met my husband. We became friends, shared our love for music and art

and eventually fell in love.

I was an art dealer and opened the Havens Gallery in South Carolina where we sold fine arts prints, serigraphs and lithographs. We did art framing and archival restoration. By the time my husband and I reached 59, we decided there was just too much to do and made the choice to focus solely on creating art, so we sold our businesses, homes and devote ourselves to our art, my husband to his art and music.

Describe a typical work-day from morning 'till night.
Now I create art and listen to beautiful music. When I ran my businesses, it was a full day of communication with customers, staff, vendors, advertisers and marketers as well as accountants and lawyers. I traveled for buying, selling and attended trade shows. Then I went home at night and drew and painted.

Are you preparing for a different career?
I taught drawing but no, I'm just going to continue my art.

Have you continued your studies?
I read constantly, always looking for techniques as they were. Whatever they are going to be, is what comes out of me. I study the history of painters, and learn about the paints they used, color mixing, techniques of the greats like Reubens and Rembrandt.

What are your current goals?
To be known. My work sells but I want to become even better known. My husband and I are on Twitter, Facebook and Instagram. We have thousands of followers and are in contact with many of them who write to us. What is art without someone to look at it? Nothing! It's the viewer that makes it.

Do you have a ten year plan?
It's later in life for me but I aim to be where I am now, in the studio drawing and painting.

Where do you see yourself living in ten years?
In the South, drawing and painting.

Do you have a twenty year plan?
In fifteen to twenty years, I hope to develop more techniques and be able to put the word out there about what it is I am trying to say. I've studied the Knights Templar, theology of that whole era – on my own for over ten years. I've studied the Bible and Dead Sea Scrolls. Some of my paintings have a direct correlation to those historical periods.

I use some art history in my work. Honore Daumier is my favorite artist. He created great gesture drawings. A museum curator called three of my paintings a medley. I call them *The Wisdom of Joy*. We often hear the phrase 'joy of wisdom'. I think it is the other way around, wisdom of joy. Joy has wisdom meaning if joy was an emotion, it would have the knowledge to be in everyone. It is a subject I am working on now.

I don't always know what will come out of my brush. I think about the content of my work, if not more than the composition, layout or color.

Do you have a retirement plan?
No plans for retirement. My husband reminds me that the word tired is in the word retired. I feel so fortunate that I can paint and don't want to squander my time. I am so excited by my work, read about it study it, sit and draw and paint.

How do you spend your leisure time?
I read about art, study it or sit and draw and paint. I would consider that to be leisure. We like good movies and study history. We have great friends we enjoy spending time with. A good meal out.

What frightens you?
Not much. There are things I don't want. I wouldn't use the word afraid, but there are things I don't like or not want to happen. I don't want to be sick, debilitated. Not being able to draw. I wouldn't say it frightens me but like everyone else, I don't want it.

What saddens you?
Nothing. I believe in God. I've had a deep faith all through my life. In Savannah, we grew up with Jews, Catholics and Protestants who went to church and temple. Everyone I knew had faith; it's with me always.

It's hard to get too sad when you have deep faith.

What pleases you?
I love people. I love my husband, family, children and dogs. I have really great girlfriends and lot of friends. While we don't see them often, we communicate with them. Beautiful painting of course, flowers, architecture and music. All the arts. I'm so fortunate to be painting while my husband is playing organ music. I love his music.

What advice would you give your younger self?
Educate yourself in life about everything. Everything that passes in front of you is very important. Learn every day, every minute. Don't waste your time – always be in learning mode.

I served on a steering committee at Columbia College to mentor young women entering the business world. My advice was to learn everything. If you are eating cereal, read the box. Learn where it was made and packaged. How is the cereal being advertised? Where is it sold? It was a good business lesson.

What advice would you give a young woman entering your field?
Go on and do it. Make your plan and do it. My father taught me that the most successful salesperson is the one who hears the most 'no's. Then you will hear 'yes.' The 'no's are part of the work. You figure out what you want to do, change to something else and simply go for it until you get it.

MY WORDS; MY VOICE
Building a life of learning and creativity. That has been my goal, my quest. Beginning that in the mid-twentieth century, I was fortunate to open a business, draw and paint, and study in upper level college courses. Women then needed to simply move forward on their own. My father always said to me, "Go ahead. You can do it!" So, I ignored what might have been constraints and built a business and a creative life. I urge all women to do the same.

Visit our gallery at **www.calkhavensgallery.com**

D is for *ental Assistant*

Gina Hernandez

Gina has spent her career in dentistry as a Dental Assistant for over 40 years. Throughout the years she has developed and maintained significant skills with the ongoing changes in the field of dentistry.

Gina currently works in a practice in Phoenix that specializes in TMJ disorders and full mouth reconstruction with an emphasis on implants. TMJ or Temporomandibular Joint is the "hinge" of your jaw that sits directly below your ears. Throughout her career as a Dental Assistant she has continued to find great satisfaction in helping her patients understand and appreciate quality dental care.

She is now approaching a time when she will be thinking of retirement but hopes she can continue to contribute to dentistry in some form or another, either through volunteering or part time work. Gina will continue to be an asset to dentistry no matter where it will take her into her future.

I met Gina at our dentist's office. She is kind, gentle and committed to her job. My husband, Armand and I actually enjoyed going to the dentist's office, in part because of our relationship with Gina. She has an endearing charm, a keen sense of humor and an interesting story to tell.

Here are her answers to the questions:

Where were you born?
I was born in Evanston, Illinois.

How would you describe your childhood environment?
I am the youngest of four children born within five years. My grandparents and an aunt were around, and I remember them as attentive and loving. I believe we had a secure happy home despite the fact that my mother was a frustrated housewife and a functioning alcoholic.

My mother was very busy. Overwhelmed with the responsibility of four toddlers, she was misdiagnosed and given Valium to offset signs of depression. After suffering a mental breakdown, she was

hospitalized for a while and given a hysterectomy at the age of thirty-seven. We discovered later she had a hormonal imbalance. In the '60s there were no support groups.

My father worked full time and went to night school. He was a mechanical engineer and worked on hydroelectric dams. He wasn't around very much.

We have always been close as a family and despite the difficult times, we were well cared for and my parents remained in love and committed to each other celebrating almost seventy-five years of marriage before they passed. I have good memories and felt secure.

As a child, what did you hope to be when you grew up?
I was shy, a daydreamer and fantasized about being an entertainer. I had a good sense of humor and discovered I could make people laugh. That gift broke the ice for me in relationships; made me feel more myself.

Did you know as a child that you would be engaged in your chosen work?
I never thought I would be in the field of dentistry. As a child, I spent a lot of time in the dentist's office, which for me was fun. I was never afraid, and those memories would serve me as an adult when it was time for me to choose a career.

Would you like to acknowledge one or more individuals who helped you shape your behavior, beliefs and work habits while on your
early journey?
The people I acknowledge from my early childhood besides my siblings and parents, are my grandparents and my aunt who provided me with confidence and a feeling of security.

As a young girl what difficulties did you have to overcome to move towards your dreams?
I had to overcome my shyness and my confusion about my sexuality. When I was 14 and had just started my freshman year of high school,

my father took a job with an international company and except for my oldest sister, Maria, the family moved to Rio de Janeiro, Brazil. Maria stayed behind because she had started nursing school and was engaged. I was terrified to leave my home and my friends.

My brother, sister and I went to the American School. We all soon adjusted and lived there four years. Being the youngest, I was the last to leave home. From Rio, my folks went to Buenos Aries. I was shipped back to Chicago.

That's when I bowed to social pressure to be normal and get married, met my daughter's father, married and gave birth at the age of 19. From Chicago, I moved to Santa Fe with my daughter, leaving my husband behind and lived with my sister Maria and her daughter until I could get my own place. My sister Carla also lived in Santa Fe and at one time all four of us siblings lived there. I loved living in Santa Fe, but it was very expensive for a single mother. I took part time jobs and for a while lived on welfare.

I was twenty when I came out to my mom first, during her visit to Santa Fe. She thought I was just going through a phase because of my bad experience with marriage. Eventually my family accepted the fact that I am gay and always respected my relationships. They are great! I am very lucky!

During my 20s and 30s I started drinking and smoking pot but like my mother I was a functioning alcoholic. In Santa Fe, I met my first long term partner and together we moved to Tucson, Arizona. Her parents lived there, and she enrolled in the University of Arizona. We were together about eight years, while I raised my daughter.

Where were you educated/trained for your work?
I went to live in Phoenix for a couple of years during that time and that's when I attended school for dental assisting.

How much training did your work require?
I spent fifteen months in school, three months as an intern. I did very well in school and love the work. I keep up to date with the

latest technology.

Once you entered the workplace, as a young woman, what obstacles did you have to overcome?
Sexual discrimination. Dental practices were mostly male-dominated. In one of my earliest jobs in a Tucson practice, after I had been employed for a couple of years, I felt comfortable enough to tell my boss I was a lesbian. I made the decision to come out to him over a casual lunch and told him I lived with a partner. His response? "I don't think you're right for this practice." Then he fired me.

As a woman, what challenges did you have to overcome?
Addiction and sexual discrimination. With my daughter as inspiration, I fought and conquered addiction to become sober and have been for decades. I fight for recognition and equality for the LBGTQ community.

Are you satisfied with your chosen profession?
Yes. I am very satisfied with my chosen profession. I've developed excellent skills and am proud to meet the dental needs of many patients.

Describe a typical work-day from morning 'till night.
My morning begins with a review of the patient schedule. I prepare for each patient. I contact labs to follow up with various dental projects, sterilize instruments and all work areas. Review new approaches for digital dentistry.

Are you preparing for a different career?
I am not preparing for a different career.

Have you continued your studies?
Yes. I read the current literature and attend seminars, training sessions and workshops to keep up to date on all new developments in the field.

What are your current goals?
My current goals are to sustain a very comfortable life with my wife, Gwen; continue our travel, stay healthy and active. I intend to work in the dental field until retirement and volunteer working with the public.

Do you have a ten year plan?
Gwen is ten years younger than I. We intend to sell our house in
Phoenix and move.

Where do you see yourself living in ten years?
Tucson, Arizona.

Do you have a twenty year plan?
Staying healthy, active and continuing to be a contributing member of
my community.

Do you have a retirement plan?
Having enough funds to live comfortably, volunteering.

How do you spend your leisure time?
Gwen and I travel once a year, take long drives, watch movies, cook,
read, do yard work and spend time with our family, friends and pets. I
like to explore my creative side, taking pottery classes and painting.

What frightens you?
President Trump, poor health, the sick and poor in America and the
state of healthcare. I live in an urban area and I feel the elderly are
disenfranchised.

What saddens you?
News, the state of our country, hate and intolerance. I am also
concerned about the condition of dentistry which many people cannot
afford. As a result, they are often forced to go to drive by clinics and
do not always get good quality of care. It's just not affordable for
everybody, why?

What pleases you?
My daughter, my biggest accomplishment in life. She is beautiful,
bright and happy. The joy I receive being surrounded by people I care
about; family and friends and pets, enjoying a good meal.

What advice would you give your younger self?
Find a better way of coping with self; stay away from drugs and
alcohol. Find a mentor.

What advice would you give a young woman entering your field?
Dental assisting is a great way to enter the field; see if you like it. It is a

progressive field, exciting and evolving.

MY WORDS; MY VOICE

I thoroughly enjoyed sharing some of my story with you, Bev. I admire your work as an author and look forward to your future works.

Women in the workplace is a subject that is important to talk about, especially in today's work environment. The times are changing for the better, we hope, for the young women starting off in their careers. I would hope that they have an easier path and the struggles and obstacles are less. It's an exciting time for young women to empower themselves and forge ahead with confidence that today's movements have paved the way.

I watch young women in my life today and see so much hope for them. Hope they bring to our country – especially the recent election. So many women being elected into office. It gives me hope.

Thank you, Bev for bringing women's voices to the forefront and all you do to contribute to the cause.

Author's Note:

Gina and Gwen married in California December 27, 2013. It became legal in Arizona October of 2014. It became federally recognized in June of 2015. Women could finally marry other women when same-sex marriage was legalized across the country. The following year, they went to Spain on their honeymoon.

Gina and Gwen fought hard for their rights and while there is a long road ahead for rule change in other states, their marriage is legally protected and recognized. They now enjoy the same rights and responsibilities as heterosexual couples. There is a sense of security and comfort in knowing their love and commitment to each other includes the ability to care for each other legally, financially and medically without interference or challenge.

Album cover design by Lititia White Moss, LTGraphics.
Photo by Mark Trupiano.

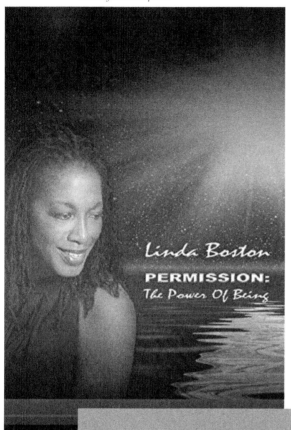

Screenshot, The Today Show 2015 with Jenna Elfman and Hoda Kotb featuring the cast of Menopause The Musical – The Survivor Tour starring Linda Boston, Megan Cavanagh, Teri Adams and Judy Blue.

E is for *Entertainer*

Linda Boston

Linda enjoys a successful career in entertainment that includes radio, theater, film and television performances. In addition, she has appeared in numerous regional and national television and radio commercials and industrial films. She is simply the consummate entertainer.

She has collaborated and performed on stage with Whitney Houston, Mary Wilson of the Supremes, Ralphe Armstrong, Dr. Dick Gregory, Tavis Smiley, Rev. Jesse Jackson and other well-known celebrities.

Linda gained recognition for her portrayal in two of the nation's most produced plays: as Mother Shaw in *Crowns,* by Regina Taylor and Professional Woman in the internationally acclaimed *Menopause The Musical.*

She was the requested vocalist for President William Jefferson Clinton as he supported the re-election of Michigan Governor Jennifer Grandholm.

Linda was also asked to prepare a special 'original' performance in Detroit for the LINKS National Convention which is an organization comprised of women of African heritage who are committed to enriching, sustaining and ensuring the identities, culture and economic survival of all people of African origin through cultural, educational and civic programs.

She was also the requested vocalist for the Detroit Branch NAACP's 52nd Annual Fight for Freedom Dinner.

Linda has received numerous awards for her work including:

2004 Detroit Repertory Theatre's Best Actress Award for her portrayal of Jackie "Moms" Mabley in the one woman show *Moms Mabley: The Naked Truth.* "It was a privilege to play Jackie "Moms" Mabley, born Loretta Mary Aiken in 1894 who was one of the most successful entertainers of the Black Vaudeville stage, also known as the Chitlin Circuit."

2013 Top Ladies of Distinction – Cite' d'etroit Chapter, Status of Women in the Arts Award.

2013 MI Youth Arts Festival Touchstone Award (VSA Michigan The State organization on Arts and Disabilities.)

Linda received her degree in broadcasting from Eastern Michigan University. Working as a primary voice over artist and broadcast law director at WJR Radio led her to a successful acting career. She continued her studies at the Detroit Repertory Theater, Atlanta's Blue Print 4 Acting school and Lace Larrabee's Laugh #15 in Atlanta.

Linda is currently playing "Neighbor Jody," a recurring character on Tyler Perry's series on BET called *The Oval*.

She has recently played "Chickie" in *You Can't Take My Daughter*, starring Kirstie Alley for the Lifetime Movie Channel.

She has appeared in other films, several of which are in production.

When not performing, Linda devotes herself to serving youth, educators and the community by linking the arts to literacy, personal growth and spiritual enlightenment. Linda's dedication to youth has her mentoring and educating them in life skills through the arts via various schools and community organizations like VSA Arts of Michigan.

In 2001 Linda established PEER, Inc. (Portable Educational and Entertainment Repertoire, Inc.) a 501(c)(3) service provider sharing the arts, education and entertainment via performances, workshops and a host of other presentations with the poor, imprisoned, group homes and schools.

Linda has been asked to serve as a mentor for StateraArts' Atlanta Chapter of an international organization, mandated to creating pathways that bring women into full and equal participation in the arts.

I saw Linda on stage in Menopause The Musical and instantly became a fan. She's simply fabulous! I initially contacted her for another project which is still in the planning stage, but we keep in touch and I am delighted she agreed to share her story.

Here are her answers to the questions:

Where were you born?
Chicago, Illinois.

How would you describe your childhood environment?
Balanced, peaceful, full of love and surrounded by music. My father
sang on the radio with a group called the Roman Rockets. He was
a meat packer who worked side jobs to support us. My mom had
a beautiful voice; she made draperies. I am the youngest of three
children. My brother was a rhythm and blues musician, a guitarist and
a service police officer. My sister sang at Chicago's famous Wonderbar
for twenty five years and still performs.

My parents fought for rights for African Americans. We grew up in the
chaos of the Martin Luther King and Robert F. Kennedy assassinations.
It was a violent time, so my parents and cousins built a summer home
outside of Chicago to keep us safe.

As a child, what did you hope to be when you grew up?
Originally, a weather girl. Something to do with television. I was
impressed by the television program *Julia*, a sitcom and the first weekly
series about an African American woman. Diahann Carroll starred as a
widowed nurse trying to raise her young son; it ran for three years. She
inspired me to think about acting.

**Did you know as a child that you would be engaged in your
chosen work?**
Yes. My family encouraged me. I was the first in my family to graduate
from a four-year college. My sister had an associate degree. As the baby,
my patriarchal and matriarchal cousins and my mother encouraged me
to do what I dreamed of. My mother expected me to succeed.

**Would you like to acknowledge one or more individuals who helped
you shape your behavior, beliefs and work habits while on your
early journey?**
My parents and cousins. Particularly my father's first cousins, Dahnial
Knight. Ella Mae and Pete Williams. Now, my encouragement comes
from my daughter. She recently told me she was proud of me.

As a young girl what difficulties did you have to overcome to move towards your dreams?
My own internal doubts. I was insecure about my height 5'10". There were no guys taller than I. Despite the fact that I was awarded an educational grant, I didn't trust myself and didn't think I could make it. I didn't have boyfriends, didn't know if I would be happy, get married or have children.

Where were you educated/trained for your work?
In college, I took public speaking and communications classes and graduated with a degree in broadcasting with a minor in theater.

After college, I worked at WJR Radio where I learned the components of acting for voice over to sell a product. Because somebody took a chance on me, I was successful in on the job training where I also learned how to write, produce voice overs and get ready to air. I learned about commercial traffic and continuity. After a while, I decided meteorology was not for me.

I took theatrical training after college by attending classes at the Detroit Repertory Theater.

How much training did your work require?
It's ongoing.

Once you entered the workplace, as a young woman, what obstacles did you have to overcome?
Insecurity about not doing well. A manager at one of the radio stations told me they didn't think I would do well in commercial work. When someone tells me I can't do something, I want to see if they are right. They weren't.

As a woman, what challenges did you have to overcome?
Procrastination. I do mirror work being accepting of me, loving the child I was. I work every day on self-improvement, being confident and sure of it. I still question decisions I made that I have to let go.

When I auditioned for *Menopause The Musical,* the choreographer

questioned my ability. She was wrong. I have been playing "Professional Woman" for almost ten years and have been internationally referenced as "The Best PW Around..." Clearly, I am my own worst critic. I still work every day to get past that.

Are you satisfied with your chosen profession?
Yes, and I want to give so much back.

Describe a typical work-day from morning 'till night.
On performance days rest is imperative. I wake up at 3:00 a.m., give thanks to the creator and meditate to get rid of negativity. I stretch my muscles, go to the gym. I relax and keep phone calls to a minimum. I'll eat fruits and vegetables. If I have two shows that day, I will have an early breakfast and fruits and vegetables which are easy to digest for the second show. After the second show, I will have a salad. I lose weight when I am on the road; usually about 3-4 pounds. I try to walk.

Are you preparing for a different career?
My non-profit PEER, Inc. (Portable Educational and Entertainment Repertoire, Inc.) is a 501(c)(3) service provider presents workshops for young performing artists. I want to tie literacy to the arts, bring theater and journaling workshops to the poor and imprisoned, group homes and schools.

Have you continued your studies?
I'm always reading and studying about performing. I take acting classes in Atlanta. I took stand-up comedy classes in Detroit and Atlanta. The SAG (Screen Actors Guild) has a wonderful library of courses. I study Spanish; I want to write and sing in Spanish.

What are your current goals?
I want to publish my husband's book, our book, metaphysically – how we are created. I promised that to him before he passed, and I need to do it. I want to keep PEER, Inc strong, write songs and write for other people.

Do you have a ten year plan?
I'm working on it. Solidifying PEER, Inc.

Where do you see yourself living in ten years?
Georgia. I plan on staying in Georgia, perhaps in a different home, a bigger house. My husband, Arthur came out of Georgia. My father was from Georgia. I love the energy. I have family here.

Do you have a twenty year plan?
Keep on going.

Do you have a retirement plan?
I want to spend time watching my daughter and grandson grow. Perhaps I'll have more grandchildren to watch, protect and encourage to be balanced in harmony and peace. To be surrounded by family and continue to work with children to heal.

How do you spend your leisure time?
I have an addiction to games on my phone. I love nature and need space to meditate and focus my mind. I find comfort in nature surrounded by trees, birds and crickets.

What frightens you?
Not being able to finish the things I want to do.

What saddens you?
This nation has not learned from its mistakes. If people don't acknowledge their past and don't know their history, they are bound to repeat the mistakes. This nation and the world seem to be at unrest. I want my grandson to be in a safe place. I want my nieces and nephews to do things they like to do. I don't like to see people being taken advantage of by fraud. It hurts me to witness child abuse and emotional, psychological and sexual abuse.

What pleases you?
Strangers full of joy. When I'm on stage and peek out from behind the curtain at the audience and they are all strangers, laughing and having a good time, it pleases me. When I take care of myself, get enough rest. When I see others taking care of themselves, like my daughter.

What advice would you give your younger self?
Don't be hard on yourself, don't procrastinate.

What advice would you give a young woman entering your field?
Meditate daily, do mirror work, know who you are. There is always something greater waiting for you; if it is meant for you it will be. It may not be challenge free, but it is right. Take care of yourself first, trust yourself.

MY WORDS; MY VOICE

You know, as we get older, experience more and see so much around us, we often compare ourselves to others, to things or to another time. Then for some strange reason, we mix that with what we seek in life. It all becomes so external. Sometimes we never grow out of that. Sometimes we never seek our intuitive mind for guidance and then find solace and satisfaction in what we have done, experienced or learned. We must find a way to accept our intuitive realities and know that what we seek, we already have. My loving husband, Arthur Morris always said that in this realm, and I hear his ancestral wisdom each and every time I second guess myself today. If you are like me, you may have been pretty hard on yourself; however, you must remember not to be. Trust me, my daily ritual is to remind:

- the child in me that I am great, and my imagination is greater.

- the teenager in me that I am beautiful.

- the young woman in me that I try hard enough and I am still beautiful.

- the older woman in me that I am one with the universe, that there are no limits and that is more beautiful than anything I could ever expect.

I have so much more in life that I want to do, want to create, want to see and age ain't nothing but a number! Just think, as a child, when I loved to listen to the radio and watch the weather forecast on television in Chicago, Illinois and Covert, Michigan, I never thought I would

be working at radio stations across Michigan, including becoming a major female voice over talent for the internationally known Ron Rose Studios and WJR Radio. That was a milestone because WJR 760 AM Radio is considered of the few remaining three call letter, Class A, 50 thousand watt, clear channel stations in the country!

When I wrote poetry in my journal starting in my teens, I had no clue I was writing songs for my CD, *Permission: The Power of Being.* Now my CD is available in several places including **store.cdbaby.com/ Artist/LindaBoston** and for download via Amazon and iTunes.

As a young woman, when I thought the only stage worth performing on was at the Detroit Repertory Theater, I never thought acting classes there would later lead to an award-winning one woman show entitled *Moms Mabley: The Naked Truth.* Today I perform regularly as "Professional Woman" in GFour Productions internationally acclaimed *Menopause The Musical* and I have traveled places I never thought I would ever go. We've performed in over forty states in the US, including Anchorage, Alaska and several places in Canada. Who would have thought our *Menopause The Musical* cast would appear on the *Today Show* with Hoda Kotb in New York?

And when all of these things were lining up, I dreamed of it but had no 'clear' plan towards doing films. Now I sit here with over twenty-five film credits and opportunities to work with some of the world's greatest in the music industry, nationally known dignitaries and Hollywood. Check out my IMDb page for more information. **www.imdb.me/lindaboston.**

To see my film demo reels, music videos and nonprofit promotional materials please visit my YouTube channel link below:

www.youtube.com/channel/UCJI3QubvHF_QM7h8_ GEzaGw?view_as=subscriber

It's all about SELF (Strong Eternal Life Force©) discovery and awakening. I am and will forever remain grateful and I trust mySELF more now than ever before. My imagination keeps rolling and the opportunities keep coming. Yes, we must take the time to rediscover

and know thySELF...and AN ATTITUDE OF GRATITUDE MUST BE AT THE HELM!

As I move through this journey 'giving back' is at the top of my list. In 2001 I established the non-profit 501c3 corporation PEER, Inc.. (http://www.peerincredible.org). PEER (Portable Educational Entertainment Repertoire©) is designed to take the arts and/or educational presentations, workshops and programming where they often are not received.

Yes, it is portable with a philosophy of creating experiences, touching others and provoking thoughts. I MUST PAY IT FORWARD! We have to remember we are works in progress in everything we do. I remind my daughter Aziza, my grandson Akhiem (AJ), family, friends, neighbors, seniors, youth, homeless and returning citizens, of these realities whenever possible. In fact, when I encounter anyone wanting to do more and go further, the ancestors whisper to me, "...share, Linda...with unconditional love." It is just that simple.

If I am there and can help, I will. Is it all reciprocal? You bet your bottom dollar it is. We reap what we sow...positive or negative. They call it Universal Law and there are at least fifty of them. Pease try not to confuse Universal Law/Love with religiosity because that is pesky. "Knowledge of good and evil" may creep in there (smile). When in doubt, research the Tree of Life, regardless of your faith/beliefs or the lack thereof. As Arthur would say, "Don't take my word for it. Check it out for yourself."

So, what is the plan? Well, know that if you are reading this book, you are working on some sort of plan. You are living some dream. And if you are thinking of what may be next for you, you definitely are not reading this book by accident. It was divinely placed in your hand by the universe, by your ancestors...by YOU!

I am thankful and most grateful for the moment I ever met Beverly and Armand Gandara. Our spirits took a plan in place, and we just "rolled with it." It has led to a wonderful kinship between us.

My husband Arthur always "says", the pen is the eye of the spirit. Beverly Gandara definitely exhibits that. My goodness, you are a constant inspiration to me Queen Beverly!

Arthur also "says," meditate, breathe, journal and respect all three of those tools. When you do, trust and roll with the flow my brothers and sisters and allow your imagination to manifest your plan. Your magnificent intuition trumps external thoughts every time, by leaps and bounds. So, remember, change manifests when we embrace intuitive thought to see our similarities...not our differences. Remember, YOU ARE the CHANGE you seek. Ase!

(©PEER INC)

Sharon and Chris Platt with Jeneria Lekilelei a Samburu
warrior from northern Kenya, a recipient of funds for
the Ewaso Lions conservation project.

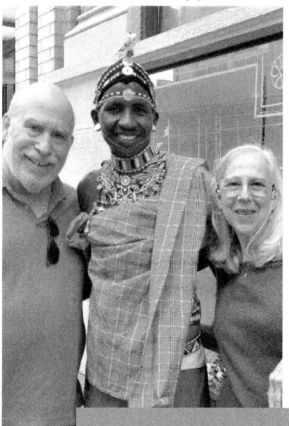

F is for
und Manager

Sharon Stallman Platt

For the past seventeen years, Sharon has co-managed, with her husband, Chris, and an associate in Great Britain, a small international charitable trust which provides grants to organizations that work with the homeless and at-risk animals around the world.

For much of Sharon's professional life she has been an educator. While in college, in Maine, she taught reading to young students on a Native American reservation. After receiving her master's degree in education with a Reading Specialization from Fordham University in New York, she taught reading to junior high school students, and communications skills, and writing and research skills to college students. Later on, she was an assistant teacher in a basic computer class.

She resides in Manhattan with her husband and two children.

Sharon is a dear friend of long standing. She is calm, kind, patient and spiritual; her chosen careers suit her well.

Here are her answers to the questions:

Where were you born?
I was born in Brooklyn, New York.

How would you describe your childhood environment?
I would describe my childhood environment as lots of fun! My dad was an accomplished artist, whose portrait of pianist Vladimir Horowitz was used on posters and the program for a Horowitz concert in Carnegie Hall. My dad was warm, loving, friendly and outgoing. My mom was a teacher, also kind and loving, but practical and organized.

My father's brother, Uncle Lou, also lived with us. Lou Stallman is a successful songwriter who wrote for The Supremes, Perry Como, Deniece Williams, Clyde McPhatter, Dion and the Belmonts, Steve Lawrence and other popular musical artists of the era. He also wrote the theme song for the New York Yankees. It was a fun and exciting time.

Our home was open to family, friends and neighbors. We had art supplies on big tables, so many of the neighboring children would come over and draw. My uncle would play guitar, so there was plenty of music and art being enjoyed.

As a child, what did you hope to be when you grew up?
As a child, I hoped to be a teacher.

Did you know as a child that you would be engaged in your chosen work?
I had no idea I would be engaged as a Fund Manager.

Would you like to acknowledge one or more individuals who helped you shape your behavior, beliefs and work habits while on your
early journey?
My parents; both of whom were inciteful, spiritual, loving, warm and friendly, guided me and instilled confidence. My mother taught me about saving and keeping organized.

As a young girl what difficulties did you have to overcome to move towards your dreams?
I had no obstacles to overcome in my childhood. It was filled with joy.

Where were you educated/trained for your work?
I attended a small college in Maine where I earned my Bachelor of Arts degree, and Fordham University in New York, where I received my masters in reading specialization, and where I began teaching.

How much training did your work require?
For me, the real education was on-the-job training, both as a teacher and a Fund Manager. I brought the same qualities I learned from teaching to managing the funds. Sensitivity, kindness and an attitude of "How Can I Help?" guides me in choosing qualified projects for funding. The fund is mandated to provide help in two areas, homelessness and animal rescue, all around the world.

Once you entered the workplace, as a young woman, what obstacles did you have to overcome?
As a young woman, starting out as a teacher in New York's Junior

High School system, I faced the challenge of having to teach children who often carried weapons to school. I moved on to teaching at the college level, which was more rewarding for me.

As a woman, what challenges did you have to overcome?
As a woman, I had no challenges to overcome. I knew my value and chose an environment that was healthy for me.

Are you satisfied with your chosen profession?
Both my careers have been quite satisfying. They've allowed me to give back to society in ways I believe I make a difference, to improve the quality of life for many people and at-risk animals, from whom others often turn away.

Describe a typical work-day from morning 'till night.
As a Fund Manager, I review proposals to determine how best to distribute limited funds to do the most good. I keep tabs on current recipient organizations and follow up on how money is spent. I visit many organizations to see how we can help.

For instance, a homeless shelter needed new a refrigerator and freezer, a farm animal sanctuary needed a new barn, and an animal rescue/ shelter needed a new spay/neuter van. We pinpoint our services towards immediate needs. We help the homeless organizations provide counseling and housing. They help their clients create resumes for work, and teach life skills. With animal organizations, we fund both sanctuaries for wild animals, and rescue, medical care and adoption opportunities for domestic animals.

Are you preparing for a different career?
I am not preparing for a different career.

Have you continued your studies?
I continue my studies on the job, as new technologies, and circumstances arise.

What are your current goals?
My current goals are to enjoy family and friends and do the best job possible.

Do you have a ten year plan?
I do not have a ten year plan. I live in the moment and stay in the present. I subscribe to Eckhart Tolle's philosophy of the "The Power of Now."

Where do you see yourself living in ten years?
I love New York City, and intend to stay here for the rest of my life.

Do you have a twenty year plan?
I do not have a twenty year plan.

Do you have a retirement plan?
This is my retirement plan, working with the fund, helping the homeless and rescuing abused and abandoned animals.

How do you spend your leisure time?
I walk several miles a day, visit museums, take knitting classes, watch the stock market, read, and exercise with yoga and calisthenics.

What frightens you?
It frightens me if I am unable to see a problem and turn it around in a positive way. I strive to feel comfortable and have that "Aha!" moment.

What saddens you?
Death and loss of loved ones saddens me.

What pleases you?
Family, friends, candy, cake and ice cream.

What advice would you give your younger self?
Whenever you are faced with a challenge, evaluate it as best as you can and let it go when the time comes. I believe everything turns out for the good. Even if you don't think it is the best outcome, it is what it is supposed to be. Don't rush to judgment, and look toward the positive, always.

What advice would you give a young woman entering your field?
Come from your heart and things will materialize the way you want them to. Come from a good place, be patient and kind. Come from love.

MY WORDS; MY VOICE

How I try to live my life.

I wake up in the morning, and I fill my body with beautiful, bright, white light, the light of health, and I extend it out to all those whom I love and want to be healthy. I think of all the things that I am so grateful for, and I appreciate my abilities and mobility.

I am grateful that I remember to hold my glass tight when I leave the bedroom so that I don't drop it and spill the liquid, and if it does fall from my hands, l am grateful that my knees bend, and that I can clean it up. I try to look at every incident as a learning experience, even if it doesn't seem so at the moment, and I try to give it enough time so that, eventually, I can look back and see the lesson I was supposed to learn.

I try to come from a place of love and support, kindness and caring. I appreciate the fact that we all come from different places and directions, and are motivated in numerous ways. I never try to change anyone, and hope that nobody would try to change me.

Standing strong in our beliefs, our spiritual and loving beliefs give us character and strength. As women, let us join together and respect and admire our individual differences and similarities. We all have something to offer, whether it's concrete or through prayer, something to be grateful for that could help this world move forward in a positive direction.

G is for
Governmental Supervisor

Susan Reiss

For a total of thirty-two years, Susan worked in local government; twenty-one years of which she served full-time as a Governmental Supervisor.

Through a series of civil service exams, she easily rose through the ranks from clerk-stenographer to accounting supervisor.

With her experience as an executive secretary before marriage and children and her positions as a volunteer in various capacities as a stay-at-home wife and mother, Susan was well equipped to return to the workforce in 1982 after raising her two children.

She took a civil service test as a clerk stenographer and scoring in the top three, she was hired to answer "suggestion letters" the town received every two weeks. She then became secretary to an innovative and challenging woman executive of the Presiding Supervisor. When she was made commissioner of a department of the town in 1989, Susan accompanied her and became part of her management team.

In 1995 that department was disbanded and Susan was hired for a position in the town Clerk's Office, which was responsible for keeping records of residents' births, deaths, marriages, dog licenses, etc. Her six month assignment was to formally close out the disbanded department which had specific government rules and regulations before it could be officially closed down.

As Accounting Supervisor for the town Clerk's Office, Susan was responsible for two checkbooks, bank reconciliations, purchasing supplies, equipment and material, overseeing the daily receipts and tracking numbers and providing a monthly report to the state.

After a few years, amongst her other supervisory jobs for her department, she was tasked with preparing the annual budget, which was a month-long process. She was given an assistant to train and supervise. By this time, she had taken three more civil service tests and continued to rise in status as Accounting Supervisor for over twenty-one years, retiring 2010.

Susan presently lives happily in a 55 plus community with her significant other.

From the time we were teens, Susan and I shared our loves, losses, blessings and challenges. As we matured, we continued our friendship, born of trust and sealed by mutual respect and love. She is energetic, devoted to family and friends and committed to any task she takes on as a volunteer.

Here are her answers to the questions:

Where were you born?
Brooklyn, New York.

How would you describe your childhood environment?
I grew up in a middle-class neighborhood. My parents owned a six-family apartment building in Brooklyn. I consider my childhood as happy and normal for the 1940s and '50s. My mother went to work when I was eight years old.

My father was a gadget person, so we had the first TV on the block, a car and a washing machine. I had a sister who was three and half years older than I was.

My mother was a wonderful cook and we ate dinner together every night and discussed the day's happenings. It was not as perfect as you would see on TV as my parents would argue sometimes about life, but it was on the whole a happy childhood.

As a child, what did you hope to be when you grew up?
My aspirations were similar to many growing up in a middle-class neighborhood in downstate New York. Find a suitable occupation in the work field until you get married and become a stay-at-home wife and mom.

From the time I saw a program on TV about a private secretary, I knew that was what I wanted to do as a vocation. We had a manual typewriter in the house, and I would pretend that I was a private secretary in a high class office – typing, making appointments for my boss, answering the phones, setting up meetings and greeting clients.

Did you know as a child that you would be engaged in your chosen work?
Yes, I was determined to follow my dream.

Would you like to acknowledge one or more individuals who helped you shape your behavior, beliefs and work habits while on your early journey?
My mother was very bright and wanted me to go to college, but I preferred pursuing my dream of becoming an executive secretary. I did go to college at night for two years in pursuit of honing my secretarial skills.

As a young girl what difficulties did you have to overcome to move towards your dreams?
I guess I was somewhat of a Pollyanna and did not consider the trials and tribulations of life as real difficulties.

Where were you educated/trained for your work?
High school and college courses. On the job training.

How much training did your work require?
I graduated from high school and immediately took a job as a junior secretary. I changed jobs approximately every two years, each time attaining a higher status.

Once you entered the workplace, as a young woman, what obstacles did you have to overcome?
Starting my work career in the early '60s, I accepted, with no malice, the role of the female, I worked at one of the few jobs acceptable for women–an executive secretary.

I then followed the flock and married. I continued to work after I got married until I became pregnant and gave birth to twins, a boy and a girl. I then stayed at home with my children – baked cookies and entertained friends and family. I was lucky and married my soulmate. We loved and liked each other. He and I had equal roles in our relationship. No one was the "boss" of the other.

As a stay-at-home wife and mom, I became a volunteer in various capacities.

I served as a board member, vice president and then president of a Long Island section of a national organization. I was also treasurer of our local PTA and class mother in my children's school.

During the late '70s, the work environment in metropolitan America changed. Women became an integral part of the workforce. They went back to school and got degrees in some areas that were reserved for men. They were not readily accepted. However, with grit and fortitude they eventually succeeded. Women became important to the working establishment. I went back to work part-time as a design typist for a market research firm.

As a woman, what challenges did you have to overcome?
The challenges I had as a woman came in the form of earning respect for my thoughts and ideas from some males. Especially in some of the minds of the religious sector and of men who were in high positions and occupations. I overcame the usual disdain of "Oh, she is only a woman."

Are you satisfied with your chosen profession?
Yes. My work experience has given me confidence, knowledge, and pleasure in pursuing my goals and dreams. I did enjoy a few of my jobs, but not all.

Describe a typical work-day from morning 'till night.
My daily work encompassed checking my assistant and making sure her daily work was done, purchasing items needed for the entire department, researching future needs, writing reports, doing complex bank reconciliations, writing checks, attending and setting meetings, preparing budgets, etc.

Are you preparing for a different career?
I am not preparing for a different career in the business world.

Have you continued your studies?
My studies are centered around enjoying myself which is a life-long endeavor.

What are your current goals?

My current goals are to enjoy my retirement, travel, read, interact with people, fight for what I believe in and be a vital part of our condominium's Social Committee.

Do you have a ten year plan?

Same as my immediate plan...stay healthy, enjoy friends and family to the fullest.

Where do you see yourself living in ten years?

I intend to live in my Long Island, New York community to the end.

Do you have a twenty year plan?

Same as my ten year plan.

Do you have a retirement plan?

I am retired. I am presently living happily in a 55 plus community with my significant other and share the responsibility of a Social Committee with two other residents. We bring parties, trips and various entertainment acts to our new surroundings. In my second stage of life I have found family, new friends, continued long-standing friends and a wonderful way of living. No further retirement plan.

How do you spend your leisure time?

My leisure time is spent belonging to a book club, playing Mah Jongg, Canasta, going out to dinner, shows, movies and spending quality time with friends and family. I volunteer my services and expertise on the Social Committee as a Board Member.

What frightens you?

Trump and his entourage.

What saddens you?

How people treat each other with disregard to human respect and kindness.

What pleases you?

What pleases me is life in general.

What advice would you give your younger self?

My advice to my younger self is be happy, productive and live life to

its fullest as much as you can. Find an occupation that you can enjoy and be diligent about your work–be proactive but not too pushy. Find friends that you can interact with and with whom you share the same values. Laugh a lot and love deeply.

What advice would you give a young woman entering your field?
Work to the best of your ability. Volunteer for a worthwhile organization.

MY WORDS; MY VOICE
I encourage all who read this book to be "True to Thine Own Self." Try to be ethical and follow your desires if you can. Don't shy away from your ideas but always get all the correct information if you are presenting a new or innovative program.

In your private life, choose people who have the same goals and spirit as you do. But in any circumstance try and have lots of laughter and of course love.

H is for
ealth Advocate

Angela Mazzella

Angela's entire professional career has been devoted to helping others improve their health. She trained as a nurse, worked as a psychiatric nurse, a nurse manager and a supportive therapist for clients in adult homes. She has studied various forms of spiritual healing throughout her career. She is a certified spiritual counselor and a Reiki Master. Reiki is a Japanese laying on of hands healing technique by spiritually guiding the adjustment of the body's natural life force energy. Her focus is on mind, body and spiritual health.

Angela currently leads meditation and support groups in New Jersey. She has two groups at a township senior center. For three years, she led meditation groups in a fitness center at a local hospital. She looks forward to expanding her reach to children and teens.

She is a proud mom of three sons and grandmother to a grandson.

I met Angela many years ago when she decided she wanted to write a book and needed to speak with someone who had some experience. Angela is a fine writer, who has graciously shared her novel and her poetry with me. Her sensitivity and wisdom are born of triumph over trauma and her deep desire to help others move from strength to strength as she has been able to do. She has yet to publish her book or her poetry but stay tuned.

Here are her answers to the questions:

Where were you born?
Staten Island, New York.

How would you describe your childhood environment?
Chaotic, emotionally confusing. My mother was always sick with something and often depressed; my parents were always arguing. My mother rarely approved of what I did, and my father was critical of me.

I was surrounded by relatives who lived close by. They were either criticizing my chubbiness and making me the target of their callous jokes or inappropriately touching me. One graduated to sexually abusing me. The abuse began when I was about four or five and lasted until I was seven. I told my parents about the abuse; they refused to

believe me and accused me of making up stories. It was a dark and lonely time for me.

I eventually discovered that my mother was competing with me. When I was given piano lessons in school, my mother began mail order lessons. My dad had his own band and played the saxophone. He was unimpressed with my lessons and deliberately sat next to the piano reading his newspaper whenever I practiced. He huffed and slapped his paper down whenever I made a mistake. As a result, my classical training was to please only myself. I could never play for anyone without my foot shaking in fear on the pedal.

My mother addressed my weight by insisting I needed willpower. She would put me on a diet, tell me she was dieting as well but continued to make cookies and baked sweets which she promptly shelved out of reach. She lost weight, I did not. She wore new good quality clothes and I wore her handmade hand-me-downs in dark colors so according to her I would look thinner.

By the time I attended high school, I became a bit more assertive and lost weight.

I often talked about becoming an actress; I loved the theater. I was chosen for the lead in *Annie Get Your Gun* at a local theater group. My mother promptly joined the theater group and quickly volunteered to do the makeup and perform other tasks in the show.

As a child, what did you hope to be when you grew up?
I thought about being a journalist, an artist and a writer. When I was in high school, I hoped to go to college and become a teacher, but my parents wanted me to be a secretary or just get a job somewhere and get married. According to them, as a girl I didn't warrant an education even though my mother wanted the same thing in her day.

Did you know as a child that you would be engaged in your chosen work?
No.

Would you like to acknowledge one or more individuals who helped you shape your behavior, beliefs and work habits while on your early journey?

The director of the local theater group gave me the confidence I needed. I didn't think I was good enough, but a friend pushed me into it and when I went for the audition, I was shocked to discover I really did have talent.

All the spiritual teachers I had along the way also taught me so much and I feel blessed that I had been directed to authentic spiritual guides such as Herman Quinones, David from Colorado, all the people at Catholic Charities, especially the Director of Social Services who saw something in me that led me to working with the mentally ill.

A high school classmate, Carol Keene DeRoss who encouraged me to attend nursing school which gave me the credentials to do the work I eventually came to love.

Sophie, my therapist who dragged me back to life after helping me work through the sexual abuse.

As for my writing, Beverly Gandara was the first person to even entertain the fact that I could publish my work. Bev continues to support my dreams; I am still writing and have faith I will someday be published.

As a young girl what difficulties did you have to overcome to move towards your dreams?

I had no self-confidence. I felt unattractive and my family reinforced that.

I was denied the education I hungered for because my father flatly refused to entertain such an idea, feeling it would be a waste because I was a girl.

Pressure from my parents to be a secretary and get married. I received a scholarship for a secretarial school which I refused because it wasn't what I wanted.

Where were you educated/trained for your work?
Carol, my classmate, invited me to an open house at Lenox Hill
Hospital in New York City for potential nursing students. I felt nursing
would be a good fit for me. Because it only cost $625 for three years, my
father agreed.

Nursing led to psychiatry for which I had a natural skill, discovered
during my specialty training at New York Hospital in White Plains,
New York. After graduation, I started out as a pediatric nurse (all that
was available but too painful for me) and then from there went to
the Public Health Hospital and trained as an Operating Room nurse.
I loved it but I was allergic to either the soap or gloves and had to
give that up. I took some courses for a teaching degree, but my father
demanded that I get a good job and stick with it.

Returning to my first love of mental health, I applied for a job at the
Catholic Charities Family Services in Manhattan and was "mistakenly"
sent to the Child Guidance Clinic. The Director created a position for
me as an Intake Worker, Assistant to the Neurologist, Scheduler for
the Social Workers and Purchasing Agent for play therapy supplies.
I learned about social workers and mental health. I loved the job. I
worked there until I got married and moved, but according to my
husband "Too far away in New Jersey to fulfill my wifely duties," and
had to quit a job I loved.

I was studying for a BS in psychology hoping to get a degree in social
work or a PsyD. I was only "allowed" to do that because my husband
felt I would at least make a good salary, but I had to quit until my
divorce was final after three children and twelve years of marriage.

Continuing on the job training, I had another job at an inpatient psych
unit in Mt. Carmel Guild, Newark, New Jersey. A few years later, I
took a job at a new in-patient psych unit at Staten Island Hospital and
within six months was promoted to nurse manager, a position I held for
five years.

My next position was as an assistant to the Social Workers and
psychiatrists and also a supportive therapist for clients in adult homes
in Brooklyn.

An opportunity in Florida arose as a psychiatric nurse to help set up a mental health program in West Palm Beach, which never materialized and from there I became the manager of an urgent care center in Lake Worth, Florida.

While in Florida, I became involved with several spiritual teachers, studied guided imagery and became a Reiki practitioner. I also became certified in hypnotherapy, all of these teachings to be applied to healing not only spirit but the mind and body as well. I felt very much at home with these practices and when I returned to New York, I became a certified spiritual counselor and earned a certification as a Reiki Master.

How much training did your work require?
My work has taken place in stages over time and none of the learning for such work ever ends. As you grow, you learn.

Once you entered the workplace, as a young woman, what obstacles did you have to overcome?
The pressure of my father's restrictions and demand that I marry and go to work to suit his needs without regard to mine.

Fortunately, in the workplace – none. I was blessed to work with colleagues who were enlightened mental and emotional healers.

As a woman, what challenges did you have to overcome?
In general, in the workplace, male domination and disregard; lower salaries than I believed I was worth, especially when I moved to Florida. Physicians with inflated egos and even less regard for nurses and/or anyone who questioned the quality of their work.

Politics and my own burn out suggested I move to a safer environment after a job at an inpatient psych unit in Newark, New Jersey and five years as a nurse manager at an inpatient psych unit at a hospital in Staten Island.

I learned more about politics and the slow crawl uphill to help improve the lives of residents in the most degrading environment I had ever seen as an assistant to social workers and psychiatrists and as a supportive therapist for clients in adult homes in Brooklyn.

Without credentials and further education, I had nowhere to go. I applied as a psychiatric nurse for a new mental health program in West Palm Beach, Florida. Unfortunately, the psychologist was more interested in making a name for himself and the program never materialized.

As for my spiritual and meditation work, very few facilities understand that such work is more about the person's experience than the credentials they require which in most cases have little to do with meditation and spiritual counseling. Some facilities required a master's degree in athletics and body work.

Personally, my husband's restrictions about my work.

Finally, at the age of fifty, I began dealing with the deep-rooted damage and anguish of sexual abuse, through therapy. I was enraged and in pain. Again, I told my parents, but although this time they believed me, they were furious with me for bringing it up. They denied that they knew at the time, claiming their innocence and accusing me of hurting them. I reminded them that I had cried to them about it as a child and all they said to me was, "There are enough problems in this family. We don't need any more." They and other family members who wished me ill, cut me off for several years. The important thing is I healed. While some of the relatives have clumsily tried to make peace, I have never received an apology from anyone.

Are you satisfied with your chosen profession?
Yes. After years of experiencing several types of meditation techniques, I understand I was guided to do this work. I had dreams of other professions, but I accept with grace where I am today. I love the people in my groups, and I feel their love and gratitude. What I give to them, I also give to myself. They force me to practice the teachings I give to them as well. My only regret is the little time I have left to do more to reach out to young people. I do believe that will come soon, even at this late stage of my life. I am finally doing what I truly love.

Describe a typical work-day from morning 'till night.
On the days I run my groups, I review my notes for each individual, study and keep up with evolving techniques. I continue my writing

and do whatever tasks are required for everyday living.

Are you preparing for a different career?
No. But I am working on increasing the number of groups I have.

Have you continued your studies?
Yes.

What are your current goals?
I am considering doing more support groups which my meditation groups sometimes end up becoming.

Do you have a ten year plan?
No.

Where do you see yourself living in ten years?
In a large house on a few acres where I can do all my meditation and support groups, have workshops for people, particularly children and teens; perhaps in Florida.

Do you have a twenty year plan?
No, I'm too old for that.

Do you have a retirement plan?
No.

How do you spend your leisure time?
I am involved with my children and grandson, writing and learning new technology.

What frightens you?
Loss of memory and having to depend on others. Having to live with one of my sons frightens me. I have at times and it is too confining. My hearing is poor and even with hearing aides, I need the TV up louder than anyone else can stand it. I want my freedom until the end.

What saddens you?
The state of the world and our country; the world we are forcing on our young people. The way we treat each other, the intolerance that is so pervasive, the greed and fraud that is daily coming to light. The lack of values in every profession and religion.

What pleases you?
The good when it comes to light.

What advice would you give your younger self?
I don't think that works for me. We learn as we grow and complete our journey in each step we choose to make at the time, so for me looking back and saying how I should have been and what I could have done is too frustrating for me.

What advice would you give a young woman entering your field?
Work on yourself before you begin to help others and never feel you are done.

MY WORDS; MY VOICE

I love what I am doing now, hearing the stories and guiding others to have more peace and healing in their lives. It brings me such joy and as one man recently told me "This isn't so hard." I applaud these men who spurned such beliefs when they were young, come seeking to learn and grow now.

More people are hungry for peace, for ways to heal themselves, relieve pain with simple tools that are available within themselves. I feel blessed that at this late stage of my life, rather than becoming useless and old, I am doing this wonderful fulfilling work. What a great way to go out!

I is for *Importer*

Honora Levin

For over twelve years, Honora (Honey) imported and sold the magnificent pottery of Mata Ortiz, a small village in the state of Chihuahua, in Mexico. These potters, who were part Indian and part Hispanic, lived in the area of Casas Grandes where a famous 12th century settlement was discovered. The native peoples made incredible ceramic artifacts which the villagers copied. Smitten with the beauty and creativity of their handwork, Honey not only imported the pottery but educated people the world over, about the art movement that was taking place there.

While it was fun and profitable to be part of the art world, Honey soon discovered that all the other vendors were men and she was challenged to break the stereotype of a "man only" trade. After a while, she gained respect for her good taste in selecting the best of the best pieces for her clients.

Honey received her Bachelor of Science in Education from Temple University and prior to her importing business, she taught for the School District of Philadelphia in the capacity of a homebound and hospital teacher. Students on her rolls had physical or psychological disabilities which prevented them from attending classes, either on a long term or short term basis.

During that time, she earned her masters degree in library science from Villanova University and started a research firm in the fields of business, medicine, law and political opposition research. Her clients included individuals with the "need to know" as well as business professionals.

After she took an early retirement from teaching, she became a sales rep for a medical equipment company and developed a brochure for the medical professionals who were to become referrals. Throughout all of her job experiences, she had to produce marketing materials in the form of print ads, press releases business cards, pamphlets and brochures.

Finally, upon moving to Arizona and never content to be idle, she learned about the magnificent pottery of Mata Ortiz. Again, her English skills and creativity came to the fore and she turned that discovery into a thriving export-import business that continued for many years.

"I suppose you could say that my job experience has been an 'eclectic' one–from teaching to research to marketing to becoming an importer and an author. Each one had its own challenges and obstacles to overcome but I am so glad to have had these opportunities. That is my story." said Honey.

Honey resides in Arizona with her husband Sid. Besides her volunteer work, she has returned to teaching part-time.

I met Honey in Arizona and we became friends. Honey helped open the door for me when I decided to convert one of my screenplays into my first novel. She had just finished her first book "The Friction Within; How the Political Divide in America Affects Personal Relationships" and introduced me to her publisher. She has been a great supportive friend. She's bright, assertive and kind and I thoroughly enjoy our relationship.

Here are her answers to the questions:

Where were you born?
Philadelphia, Pennsylvania.

How would you describe your childhood environment?
Loving and caring but strict as far as rules of behavior go.

As a child, what did you hope to be when you grew up?
A Switchboard Operator.

Did you know as a child that you would be engaged in your chosen work?
No.

Would you like to acknowledge one or more individuals who helped you shape your behavior, beliefs and work habits while on your early journey?
My husband. I didn't have a clue about running a business, but he was

an executive of a twenty-six drugstore chain and had lots of experience in marketing, inventory, pricing, etc.

As a young girl what difficulties did you have to overcome to move towards your dreams?
In my teens, I wanted to be an interpreter at the United Nations, but when I enrolled in Teacher's College, I was not allowed to minor in Spanish.

Where were you educated/trained for your work?
After receiving my BS in Education from Temple University, I attended Villanova University and earned my masters degree in Library Science; my field of study being Library and Information Science. My thesis was in the field of "information broker." This was an emerging field in free-lance researching in specific or general fields such as: law, business, medicine and health, literature, politics, marketing and serving anyone who had "the need for accurate and timely information."

How much training did your work require?
My education helped, but most of the training was on the job. I first researched the art movement through interviews, books and valued opinions.

Once you entered the workplace, as a young woman, what obstacles did you have to overcome?
Until I became an importer my early jobs did not present too many obstacles.

As a woman, what challenges did you have to overcome?
As an importer, I was the only woman trader in the Mata Ortiz art movement. I stood out from the men because I had better luck selecting my pottery inventory.

Are you satisfied with your chosen profession?
Yes. It was an exhilarating experience that led to meeting not only people from a new culture but interesting collectors as well. But I am disappointed that the product is now sold everywhere which is good for the potters, but the prices are undervalued. I am no longer in the importing business.

Describe a typical work-day from morning 'till night.
My days were spent doing the following activities: Filling orders, packing shipments, labeling to buyers all over the country, marketing in art magazines, trade shows, museums, etc.

Are you preparing for a different career?
Yes.

Have you continued your studies?
No.

What are your current goals?
Continue teaching twice a week.

Do you have a ten year plan?
No. I just stay busy.

Where do you see yourself living in ten years?
Arizona or Israel.

Do you have a twenty year plan?
No.

Do you have a retirement plan?
No.

How do you spend your leisure time?
Exercising, meeting friends for lunch or dinner, reading, watching Netflix and keeping abreast of politics.

What frightens you?
Islamists, the Democratic Party.

What saddens you?
The decline in our country.

What pleases you?
I am happy to be alive, healthy and loved by a wonderful spouse and two daughters.

What advice would you give your younger self?
Have the confidence to learn new skills.

What advice would you give a young woman entering your field?
Competition is keen and branching out into other areas can help.

MY WORDS; MY VOICE
My move to the southwest, Arizona in particular was a very positive
one. First of all, I discovered a whole new area of the country that
I knew little about. My first entrée into this area was enrolling in a
learning program for guides at the Heard Museum. I was a guide for
five years until the demands of my import business overcame the
amount of time I had to spend giving tours.

I now have a firm and broad knowledge of the history of the southwest,
the culture of the Indian Tribes that came here about 2000 years ago
and the incredible sites that are everywhere in the southwestern states.

Arizona is a mixture of people from all over the United States as well
as a real diversity of world populations. This move has expanded my
appreciation of many cultures and has added to my friendships. I take
pride in having contributed to the expansion of the Mata Ortiz art
movement in its infancy because of what I learned by moving to this
area of the country!

With permission from Magna Wave PEMF, Louisville, KY.

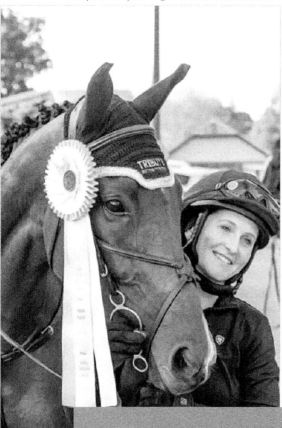

Photo by: Jim McCue/Maryland Jockey Club.

Photo by: Samantha Clark.

J is for *Jockey*

Rosie Napravnik

At 5'2" and weighing in at 113 pounds, Jockey Rosie Napravnik is one of the nation's best, having competed in the male-dominated sport of Thoroughbred Racing.

Napravnik began racing under the name A.R. Napravnik – "so no one would know I was a girl." She earned her first victory at Pimlico Race Course on June 9, 2005, aboard her first-ever mount, RingofDiamonds, just days after finishing her junior year of high school.

The daughter of Charles and Cindy Napravnik, she grew up around the barn as her mother, an accomplished horse woman in her own right, trained three day eventing horses and managed a boarding and training facility in Bedminster, New Jersey. Rosie was in the saddle as a toddler and competed from the time she was three or four years old and participated in Pony Club events in her area. Her sister Jasmine "Jazz," six years her senior, led the way into faster-paced events like pony racing, and it wasn't long before Rosie felt the need for speed.

While the pioneering female riders were paving the way, Napravnik traveled cross-country to Maryland, Virginia, and Delaware to participate in pony races, which were held at steeplechase meets. She trained her race ponies as if they were thoroughbreds. Napravnik competed on ponies until she graduated to riding the junior horse circuit. She also spent time exercising horses for renowned trainers like Jonathan Sheppard and Dickie Small who recognized her talent as a jockey.

When Napravnik turned sixteen, she took out a license with the National Steeplechase Association and learned to ride training flat races during the steeplechase meets. That summer she moved in with her sister, who was working as an assistant to thoroughbred trainer Holly Robinson, to gallop horses. Coaching from Robinson and Small led to her taking out her jockey's license when she turned seventeen.

Although she won immediately, she sustained the first of five serious career injuries. But that did not prevent her from continuing to ride and in 2006, Napravnik swept the rider standings at all four meets at Pimlico Race Course and Laurel Park and was runner-up to Julien Leparoux for the Eclipse Award as outstanding apprentice jockey.

In 2010 Napravnik was the top jockey at Delaware Park, where she scored her one thousandth career win on Laughing Charlie on October 27, 2010. Earlier in the year, she became the first female jockey to win a graded stakes race at Lone Star Park when she piloted Redding Colliery to victory on May 31, 2010. Then it was time to try a new challenge – New Orleans, where agent Derek Ducoing put her on 110 winners (her closest rival, James Graham, finished with seventy-six).

Rosie Napravnik took the sports world by storm in 2012, wrapping up an incredible season by landing in the highest spot ever for a female jockey on the year-end North American leaderboard. Her $12,451,713 total put her in eighth place in purse earnings.

That magnificent 2012 campaign was highlighted by a pair of memorable conquests. On May 4, 2012, Napravnik became the first female rider in the 138 year history of the Kentucky Oaks to capture that storied race. She brought home the race's signature garland of Lillies aboard the Larry Jones trained, aptly named filly Believe You Can.

Then, on November 3, 2012, Napravnik became only the second female rider in history to win a coveted Breeders' Cup World Championship race when she piloted eventual Eclipse Award winner Shanghai Bobby to a nail biting victory in the Breeders'Cup Juvenile. It was the fifth win in Shanghai Bobby's undefeated 2012 campaign. Napravnik was on board for all five.

As if becoming the first woman in history to win the $1 million Louisiana Derby and subsequent meet title at the Fair Grounds Race Course & Slots in 2011 wasn't enough, Napravnik went on to capture her second consecutive Fair Grounds meet title in March 2012 with 111 wins. She added a third in March 2013 with 125 wins.

The 26-year-old phenom followed up a record-breaking 2012 campaign by making history in 2013–becoming the first female jockey ever to contest all three jewels of the Triple Crown, the Preakness Stakes, the Kentucky Derby and the Belmont Stakes.

Rosie finished the year with an amazing 269 wins, placing her fifth among all North American jockeys and a year-end purse earnings total of $13,242,202 which placed her eighth in the North American standings. Her extraordinary 22% win was the highest among the top 25 jockeys on the earnings leaderboard.

Madison Avenue took notice of the fresh-faced, charismatic young superstar and teamed her up with SNICKERS, and Wild Turkey. Rosie was the subject of a *60 Minutes* profile, and a *New York Times Magazine* feature.

Rosie retired from racing after winning her second Breeder's Cup in 2014 on Untappable to raise a family with her husband, Joe Sharp.

Since her retirement Rosie has taught galloping clinics for Young Riders camps and led seminars on "Transitioning Thoroughbreds From The Racetrack" and "What Race Horses Know." She has been a keynote speaker for various events, including the National Pony Club Convention.

Rosie sits on the Board of the Retired Racehorse Project and the Advisory Boards of Old Friends and the Makers Mark Secretariat Center. In early 2019 Rosie partnered with New Vocations Racehorse Adoption Program to open a satellite facility in Covington, Louisiana where she recognized a high demand for thoroughbred aftercare in the area. She is a thoroughbred equestrian advocate providing an outlet for them as they retire from racing.

I read about Rosie on the Internet and am impressed by her commitment, courage and strength competing in and rising to the top of a male-dominated profession as a jockey, while overcoming discrimination and several injuries. I admire her care and concern for the aftercare of thoroughbreds. She's smart, gracious and delightful to work with. I am happy she agreed to share her inspiring story.

Here are her answers to the questions:

Where were you born?
Mendham, New Jersey at my grandmother's house. I grew up in High
Bridge, New Jersey.

How would you describe your childhood environment?
Wild and free. I grew up on a farm in Bedminster, New Jersey on a
large boarding and training facility for horses run by my mother.
My father is a farrier. (A farrier specializes in shoeing horses, caring
for their hooves and providing general veterinary care for them as
well.) My brother, sister and I had a lot of activities outdoors. It was
a very fun loving childhood with great memories. At a young age I
experienced a lot of independence.

As a child, what did you hope to be when you grew up?
I was riding horses as a toddler and was seven years old when I
decided I wanted to be a Jockey and set a goal to be the first woman to
win the Triple Crown.

**Did you know as a child that you would be engaged in your
chosen work?**
Yes.

**Would you like to acknowledge one or more individuals who helped
you shape your behavior, beliefs and work habits while on your
early journey?**
My parents, particularly my mother who trained me, was and
continues to be a great influence. My siblings and I from a young
age all worked for what we wanted to do with full family support.
I learned a lot from my older sister about becoming a professional;
someone who people naturally wanted to give opportunities to. As a
young teenager, I was successfully interacting with adults.

**As a young girl what difficulties did you have to overcome to move
towards your dreams?**
I put pressure on myself at a young age. I remember trying to figure
out when to put pressure on and take pressure off. My parents listened

to me when they asked me "What is it that you want to do?" They supported me in my decisions and provided guidance on how to get there.

Where were you educated/trained for your work?
Horsemanship is the core of that. From the age of two, I was introduced to horsemanship by my parents who were great influencers. Their work with horses gave them the knowledge, expertise and respect for horsemanship which they passed onto me and which provided me with a strong foundation in horsemanship that I have carried through my entire career.

My mother was my riding instructor. My first job was riding in the summers for Jonathan E. Sheppard a well-respected horse trainer, inducted into the National Museum of Racing's Hall of Fame in 1990.

Training comes with experience, working for different people. It's hard to simulate what you learn, all the different steps. There are jockey schools but they are not overwhelmingly influential in this country.

How much training did your work require?
My training is ongoing. When I turned sixteen, I was old enough to be licensed by the state to work at a racetrack. With approval from the trainer and the outrider, I was granted a license. Basically, an outrider at the track is responsible for the safety of the riders and the horses during training and live racing. Some people watch out for you, some people don't.

Once you entered the workplace, as a young woman, what obstacles did you have to overcome?
When I entered the professional workforce at sixteen, I didn't have a driver's license. (Minimum age requirement was seventeen.) I was still in high school. For the summer, I went to Maryland to live with my sister who was working as an assistant to thoroughbred trainer Holly Robinson, to gallop horses. I exercised the horses. When I turned sixteen, I took out a license with the National Steeplechase organization for permission to work at a racetrack, but I had to be driven everywhere.

I learned to ride training flat races during the steeplechase meets. Holly sent me to work for Dickie Small, another well-respected trainer. He suggested I had potential and encouraged me to start my racing career right away; I applied for and received my Jockey's license.

I hadn't planned on staying at the racetrack after my summer job. Coming of age in the real world so I could continue my career took me two weeks past the school year. I was a junior in high school and working at the racetrack in the morning during school hours.

I contacted the principal at the local public high school, explained that while I wanted to continue my education, I was beginning my career as a professional jockey and we worked out a schedule for me to do both.

I worked at the racetrack from 5:30 to 9:30 a.m. every morning, attended classes from 11 a.m. to 2:30 p.m. in the afternoon and night school from 6-10 p.m. I had to be driven everywhere from the house to the racetrack, and back and forth to school. I am grateful to my sister for driving me back and forth while I attended night school. I completed my junior year, began my professional career as a jockey and had immediate success. I earned $100,000 riding races in what would have been my senior year of high school. The following spring, I earned my GED.

I won immediately, but also sustained the first of five serious career injuries, when my mount tripped over a fallen horse at Laurel Park on November 12, 2005. I had a broken collarbone and was out for five weeks.

As a woman, what challenges did you have to overcome?
I had to learn how to become a responsible, professional athlete. I had to keep my weight down. The first year I was an apprentice jockey, I weighed 108 pounds, ten pounds lighter than a journeyman (more experienced) jockey.

Discrimination: In the beginning, Dickie Small suggested I ride under my initials, so people wouldn't know I was a female. I was just thrown into the mix. It was a difficult way to get in, but I went through the injuries, the unsuccessful intimidation by some of the male riders

during a race and began to make a name for myself as a winning jockey.

Trainers from out of town solicit jockeys to ride for them by reading the jockey standings, such as leading jockey, second leading jockey, etc. The leading jockey gets a lot of business. Some trainers would say to me, "Hey, no offense, I don't ride girls." I never took offense. I kept my head down, kept winning races and they could no longer ignore that. I was the leading jockey at almost every meet. I was winning so many races they eventually came to me. I had plenty of opportunities to ride. The percentage of races won, and money earned were more important than who the jockey was.

I don't know what the guys in New Orleans thought of me before I arrived. I'm sure they heard I'd ridden in New York and Maryland and done well, but you don't really know that or believe it until you ride with someone and can see for yourself that they can be competitive. The boys down there tested me a bit when I first got there. But all I did was keep my mouth shut and push back. And by the end of the Fair Grounds, I really felt like everybody was happy for me having won the meet and won the derby. The success and leading rider titles mean a lot to other people. Even the guys who gave me a hard time in the beginning developed respect for me, and I appreciate that, because a lot of times when you do well, you don't have friends.

Injuries: My first injury was a broken collarbone which occurred when my mount tripped over a fallen horse at Laurel Park on November 12, 2005. I was out five weeks.

On January 26, 2007, at Laurel, I suffered a spinal compression and fractured vertebrae when my mount, Look Out Lorie, collapsed past the finish line with me on her back. I missed three months and had barely returned to riding when, on July 6, 2007, my mount broke down resulting in a broken wrist and finger. That injury caused a four-month layoff and was the most painful I'd ever experienced.

I led the standings at Laurel Park in 2008, but on August 2 of that year, I broke the tibia and fibula bones in my left leg in a race at Delaware. I

was sidelined for three months, but I came back off that injury strong, and mentally I was just ready to go back.

I underwent multiple surgeries on a broken left arm incurred in a July 6, 2011 spill at Delaware Park. It required four surgeries on the fractured radius and dislocated ulna due to complications from compartment syndrome, a painful swelling and retention of fluids. Fortunately, there were no complications with bone structure and I resumed riding that October.

Are you satisfied with your chosen profession?
Absolutely. During my career I got every opportunity I deserved and was able to experience the best of horseracing.

Describe a typical work-day from morning 'till night.
I was usually at the track by 5:30-6 a.m. to breeze about one to ten horses for different trainers. Horses in training do sprint drill breeze or work outs about out once a week leading up to a race. Jockeys are used for the workout where the horse is run at an easy pace for about two minutes and allowed to stretch out a bit.

Around 10 a.m., I'd take a nap in the jockeys' room and prepare for the day of racing. I might have had three to twelve races. I'd handicap all races to map out a strategy.

Breakfast was toast and hot tea. I'd eat one meal a day after the races at the end of the day. I ate small to avoid an upset stomach. I generally knew in advance what my weight needed to be the next day before I ordered dinner. I'd usually have a couple of days advance notice.

Are you preparing for a different career?
I began a second career about two years ago. I take retired racehorses from the racetrack, retrain them for horse sports, show jumping, three day events, dressage (dressage is an equestrian sport where a rider and a trained horse carry out specific and controlled movements in an arena and are judged by performance,) besides being a mother to a three-year old and a four-year old and a step-mother to my husband's daughter as well.

Have you continued your studies?
Not in being a Jockey; that is gained by experience. As long as you're riding, you're learning things. I am in the very beginnings of what I'm doing now; the early stages of being a horse trainer of off track thoroughbreds. Retired horses are known as off track thoroughbreds who no longer race.

Horses live an average of twenty-five to thirty years. The average career span of a racehorse is about three years. The average retirement age for a racehorse is five years old.

What are your current goals?
I intend to further my education in three day eventing, cross country show jumping and Dressage and experience the upper levels of those sports. I am also retraining and reselling as many thoroughbreds as I can from the racetrack. I am a thoroughbred equestrian advocate providing an outlet for them as they retire Offtrack and work within the industry to give them opportunities to have second careers. I am also developing the New Vocation Race Horse Adoption Program in Louisiana.

Do you have a ten year plan?
Competing at upper levels of eventing, teaching riding lessons and continue to develop our farm in that direction.

Where do you see yourself living in ten years?
Kentucky.

Do you have a twenty year plan?
Same thing.

Do you have a retirement plan?
Asking a horse person that question, no not really. They will probably say just continue doing what they're doing and as they get older, doing less and less of the physical aspects of that job.

How do you spend your leisure time?
I have so little of it but what I do have is spent with family. We

currently live far away from most of my family and travel a lot to see as much of them as we can.

What frightens you?

I don't think about that as much as my ambitions. I discover fears as I go, rather than looking at them as obstacles.

What saddens you?

As the racing industry continues to develop and flourish, I am proud of all the positive work done over the years to protect the owners, trainers, riders and horses. Yet there are those who are not in the horse racing industry and have little to no experience with it, expressing a negative outlook which is detrimental to the profession.

What pleases you?

My first career accomplishments, opportunities I had, the decision to retire when I did, having children, our place settled in Kentucky, a happy place for family to move on seamlessly and just being as passionate about a second career. I made good decisions and had fantastic people behind me my entire life. We are as settled as we can be as we travel a lot.

What advice would you give your younger self?

Slow down. It's so hard. The first career, a second career. I didn't see it and enjoy it while everything was happening. I was so busy always chasing more and there was so much pressure. I wish I knew how much I was missing out on during the process and couldn't see what I was doing when I was doing it. I wish I could see what I was doing in the big picture, how much more I could appreciate my Jockey career.

What advice would you give a young woman entering your field?

Obstacles only exist if you recognize them as obstacles. Challenges we all encounter. There is always a way to get to where you want to go if you want it badly enough. My success was largely about recognizing opportunities and taking advantage of them.

In my career, I stood out by blending in as a woman in a male sport. By being equal as far as my ability to a man I was set apart and that was an advantage. All I had to do was be as good as the man standing next to me and I was put above them because I was a woman. For me, being a female in a male dominated sport, worked to my advantage.

MY WORDS; MY VOICE

Boundaries only exist if you believe they do. You create your own reality for success.

www.rosieofftrack.com

K is for
ennel Director

Linda Vetrano

Linda Vetrano has had a lifelong love for animals. She is a dedicated advocate for the care and safety of all animals but most of her resources are used for rescuing abandoned and abused dogs.

Born and raised in London, England, she was trained to be a businesswoman. After her move to America and her success in real estate, she focused on the care of abandoned, and abused dogs in New York City. As her reputation grew, she took full responsibility for the health and welfare of an increasing amount of dogs.

Utilizing her business acumen, she became the founder and president of Posh Pets Rescue. Since 2006, Posh Pets Rescue, a 501(c)(3) nonprofit organization, has been dedicated to the rescue and placement of homeless animals into loving homes.

Linda and her staff believe that with the right match and support, every pet and every pet parent can be Posh! Posh Pets is empowered by their network of caring foster homes, as well as their No-Kill shelter in Long Island and their Westchester adoption center.

In addition, Linda and her staff host off-site adoption events at multiple New York locations through the use of their mobile adoption vehicle. Linda has rescued dogs from China, Korea and Thailand.

I knew about Linda's extraordinary work rescuing animals from China and Thailand from a friend who has traveled with her and shares her mission to rescue dogs from being used as food and give them safe and loving homes in the United States. How wonderful of her to share her story.

Here are her answers to the questions:

Where were you born?
London, England.

How would you describe your childhood environment?
Except for the fact that my mother did not like animals, so we never had pets, my older sister and I were brought up in a normal, blue collar environment.

As a child, what did you hope to be when you grew up?
I knew how to sell what people needed or asked for. I use this approach to match an animal with people who will provide the right home for it.

Did you know as a child that you would be engaged in your chosen work?
No.

Would you like to acknowledge one or more individuals who helped you shape your behavior, beliefs and work habits while on your early journey?
I didn't have mentors or much guidance. I was very aware of my surroundings and learned what not to do as much as figuring out what suited me best.

As a young girl what difficulties did you have to overcome to move towards your dreams?
Being on my own, I guess. My mom found a new partner. When I was sixteen, I moved out and worked for an American company. I was an administrator and worked as a bartender on the weekends to support myself.

Where were you educated/trained for your work?
As a businesswoman in London. I took a typing class when I was sixteen which helped me in business. As far as my love for pets, I was very attentive to other people's pets and learned how to care for them.

The combination of business training and pet advocacy served me well as a Kennel Director. When I moved to New York, as a rescuer of pets, my first question was always "How can I help?" I learned about other organizations which were rescuing pets and joined them as a volunteer. I walked the dogs and learned as much about them as I could. Many came from municipal shelters and were scheduled to be euthanized. I took as many as I could into my home every year and paid for all the fees required to bring them back to health and comfort. I continued visiting many so called shelters and when I saw the animals caged, I took additional animals into my home.

After five years, I was advised to form my 501(c)(3) charitable organization and solicit donations to help with the mounting work and costs. It was physically and mentally exhausting.

When I developed my charity, I was still working in real estate and gaining a reputation for rescuing animals. People wanted to help and from rescuing two to three animals per year, we now help over seven hundred a year.

There were a lot of stray dogs in New York City, many purebreds. We encourage people to rescue dogs from a shelter; it's a good thing. We go through a stringent screening process to make sure animals will have a safe and loving home.

How much training did your work require?
The training is on the job and is on-going as new challenges arise that we have to meet. To begin with, I spent my whole life loving pets which inspires me. When I was able, I took in animals nobody else would take. I had to undo the bad behavior of animals who were abandoned, some beaten and tortured and turn them around to make them adoptable. I made sure they were treated medically. It is a challenge to take the worst of them and fix them.

Once you entered the workplace, as a young woman, what obstacles did you have to overcome?
Lack of experience and proper guidance.

As a woman, what challenges did you have to overcome?
Coming to a new country, earning a living.

Are you satisfied with your chosen profession?
Yes. To me it's a way of life 24/7. People got to know me and asked that I take over the shelter in Long Beach New York which had been damaged after a hurricane; animals had to be moved out. It took me one year to get it operational. The City of Long Beach, New York provided 20% in donations.

Describe a typical work-day from morning 'till night.
I check for emails regarding adoption problems and procedures,

answer questions from established adoptive or foster pet parents and potential adoptive or foster pet parents. I call veterinarians to either set up appointments for rescued animals or follow up with them for animals they have seen. I communicate with volunteers, staff and anyone who needs my attention to keep our mission on track. I visit our shelter and our rescue house to oversee animal activities. Our shelters are open to all animals of any age and size who need our help. We've housed dogs, cats, bunnies, goats and birds.

Are you preparing for a different career?
No. My goal is to save animals globally, particularly dogs in Thailand, China and Korea where they are used in the meat trade.

Have you continued your studies?
I keep up to date on all news relating to animals. I focus on educating people to bring attention to puppy mills and why they are bad.

What are your current goals?
To educate people about stray animals, spaying and neutering in states such as California and Texas where there is a need for more pet shelters, particularly in rural areas in Texas. There are reports that near the Mexican border, animals are shot and poisoned.

Do you have a ten year plan?
Continue doing what I'm doing and have a no kill rule by 2025 in the United States.

Where do you see yourself living in ten years?
New York, saving animals.

Do you have a twenty year plan?
Same.

Do you have a retirement plan?
No. I will do this until I die.

How do you spend your leisure time?
Being with the animals. Watching television or reading.

What frightens you?
Repeated behavior by individuals who have been previously warned or

punished for hurting an animal.

What saddens you?
Ignorant people who abuse animals, don't think of them as pets but as collateral or property they can sell to make money.

What pleases you?
Seeing an animal happy in a loving home after experiencing poor or dangerous conditions.

What advice would you give your younger self?
Be more head than heart.

What advice would you give a young woman entering your field?
Remember, pet rescue at any level is a business – make it work. Spend your money wisely. Keep an eye on your energy to avoid burn out. I've been doing this full time for over nineteen years and have had to learn to multitask.

There is no set schedule. I have been called in the middle of the night to take in an abandoned or abused animal. As wonderful as it makes you feel to save an animal and provide it with a good home, it is stressful. You must learn to keep your emotions in check for your own health and that of the animal.

This work is expensive. A rescued animal has to be checked medically, physically and emotionally, fed and housed. While you are aware you can improve their lives, you need money to do it and its very expensive. This work cannot be done by love alone.

I've had the experience of scrambling for money. I consider myself a smart businesswoman, but I have had to use my personal savings, so I can continue to rescue. Unfortunately, it is a cycle that keeps repeating itself. We rely on donations to cover the yearly expenses.

Poshpetsrescueny.org is often helped by small donations. We can always use pet food and other items. Follow us on Facebook and Instagram. **www.facebook.com/PoshPetsRescue.**

MY WORDS; MY VOICE

My goal is to make sure Puppy Mills are closed down and that Spaying and Neutering become mandatory across the country.

We welcome donations, small and large.

Please visit our website: **www.poshpetsrescueny.org**

Find us on Facebook!
www.facebook.com/PoshPetsRescue

Photo by: Todd France Photography.

L is for
Legal Assistant

Sally Sasso

For over forty years, Sally has worn many hats at the law firm where she works including legal secretary, secretarial supervisor, and assorted positions in Recruiting, Events and other departments. She has a track record of strong performance in high-volume, high-pressure environments. Sally is most grateful for her time spent as an executive assistant to the firm's senior partner – a role she continues to this day. Sally credits her wise boss for always leading by example. She said, "He is incredibly well educated but was never too smart to listen. He gave me great freedom to take on new challenges and continually raised the bar. Most of all, he trusted me and pushed himself as hard as he pushed his team."

Sally began her career in high school and "typed her way through college." She received a BA from Douglass College at Rutgers University and an MBA from the School of Business at Fordham University.

Sally's long history with the company made her the perfect choice to work on the firm's recently published book, *History of a Culture.* The firm's executive partner acknowledged Sally's role in the book's introduction as follows: "Sally Sasso, a 40-plus year member of our family, was indispensable in organizing these materials, arranging all the interviews and helping to provide context for this book."

When she's not at work, Sally enjoys spending time with her husband and their three children. She is also active in her community and when not volunteering, she can be found at the pool or track with her friends training for their next triathlon – and laughing throughout.

Sally and I worked at the same law firm. After over forty years with the firm, she continues to be a well-respected irreplaceable employee; efficient, kind and energetic. I miss our lunches but am gladdened by the fact that we keep in touch and she has graciously agreed to share her story.

Here are her answers to the questions.

Where were you born?
Flushing, New York.

How would you describe your childhood environment?
I was very blessed to be brought up in a very loving environment with two hard working, kind-hearted parents – and three sisters with whom I'm very close.

As a child, what did you hope to be when you grew up?
A lawyer.

Did you know as a child that you would be engaged in your chosen work?
Definitely not.

Would you like to acknowledge one or more individuals who helped you shape your behavior, beliefs and work habits while on your early journey?
My parents greatly influenced my behavior, beliefs and work habits as did several nuns/teachers (pun on work "habits") and my present boss.

As a young girl what difficulties did you have to overcome to move towards your dreams?
My parents were not college educated and encouraged my sisters and I to learn a trade. It just wasn't on their radar to send any of us to college – not that they discouraged that route. My sisters and I were sent to a Catholic, all-girls high school which my mother and father's sisters had also attended in their youth, where we learned secretarial skills. I wouldn't say preparing for and attending college was a "difficulty" I had to overcome but it was something I needed guidance on that I didn't get at home.

Where were you educated/trained for your work?
I had secretarial skills learned in high school and those skills were necessary to get into the law firm where I currently work. I did need additional education in order to be given additional opportunities to move around at the firm.

How much training did your work require?
I had a high school degree but needed more experience to work for
my current boss. I was eager to learn and having had successful work
experiences with other attorneys at the office, gave me some credibility.
My current boss wanted to hire someone with a college degree and
fortunately I was just finishing up my coursework and had earned
a bachelor's.

**Once you entered the workplace, as a young woman, what obstacles
did you have to overcome?**
I was young when I started working at the office (part time while in
high school – I was sixteen years old), so I would have to say that
proving that my age wasn't an obstacle was the first order of business.
I was up to the task. Unfortunately, there were a handful of attorneys –
fresh out of Ivy League law schools – that were quite full of themselves
and didn't necessarily feel someone with a secretarial degree was very
bright. I learned early on that not everyone was lucky enough to be
taught the importance of treating others with respect and how you
would want to be treated. There were some bad apples out there.

As a woman, what challenges did you have to overcome?
Back in the early days, I witnessed and was on the receiving end of
some serious sexual harassment. Inappropriate comments were made
to say the least. Fortunately, thanks to plenty of training and education
that's now required – and that there are repercussions for poor
behavior, there may someday be an end to this behavior.

Are you satisfied with your chosen profession?
Honestly, no. Although I did change my plan to attend law school –
and got an MBA instead, I am grateful to have had the opportunity to
work a flexible schedule which allowed me to be home with my young
children – for that benefit, I would do whatever it takes.

Describe a typical work-day from morning 'till night.
When my three children were young, my days were a whirlwind. Early
to rise to work out with another neighbor/working mom – then the real
work began – getting the kids ready for their day, dropping off with

the sitter (my Mom gratefully!), off to school, whatever. I had to be in the office early – for a demanding (yet understanding) boss who had my desk full of work by 8 a.m. I'm happy to say that technology made my job easier – having a phone to use to answer emails etc., while commuting was a game changer. My flex schedule allowed me to run out at 5 p.m. to catch a train, grab the kids, throw dinner together and on and on.

Are you preparing for a different career?
Not at this stage – but looking forward to some volunteer work.

Have you continued your studies?
I earned a BA and an MBA.

What are your current goals?
I'm devoted to my boss who is at the end of his career and my plan is to stay at it as long as he does. I'm fortunate to have been given other opportunities to get involved in interesting projects at the office (events, business development) and that makes me feel more satisfied with where I am at this stage.

Do you have a ten year plan?
At my age, just to stay involved and healthy!

Where do you see yourself living in ten years?
I'm thinking perhaps I'll be retired, living in a different state and doing some rewarding volunteer work. Maybe even taking some college or continuing education classes.

Do you have a twenty year plan?
Staying alive and healthy.

Do you have a retirement plan?
Enjoying time with my husband and family – and hopefully some vast traveling too.

How do you spend your leisure time?
I have a dynamic group of close-knit girlfriends and we push each other to try new things. We are very active and have now completed several triathlons and are constantly looking for fun ways to challenge ourselves both intellectually and physically. They make aging fun.

What frightens you?
Jellyfish and snakes.

What saddens you?
Seeing my parents age – and close friends and family get sick.

What pleases you?
Laughing, working hard, using my brain, being physically active,
spending time with friends and most of all being with my family and
making them happy.

What advice would you give your younger self?
Live in the moment, don't be afraid to try new things and continue to
challenge yourself.

What advice would you give a young woman entering your field?
Don't limit yourself. Continue to use your brain and push yourself. You
can do anything you set your mind to.

MY WORDS; MY VOICE
My company no longer uses the term "secretary" – the new title used
for this role is "legal assistant" and/or "attorney support." Decades
ago, when I finished my college degree and was moved from my role
as Assistant Secretarial Supervisor to my current position (I was an
Assistant Recruiter before that), our Human Resources director gave
me the title of "executive assistant" as she felt it more accurately
described my role working for our senior partner. I honestly was
never terribly impressed with the title. Sadly, I think it was because
I wasn't exactly thrilled with my role – although I admired my boss
greatly, learned a great deal from him (and continue to do so). I was
most appreciative of the fact that he believed there wasn't anything I
couldn't do. He would assign tasks to me that would normally not be
given to someone in my role (not because the person wasn't capable
of it but because it just wasn't done, typically). For example, my boss
thought it would be a good idea for the Firm to put together a brochure
of the volunteer and extra-curricular projects that our attorneys were
involved in. This could easily have been done by the Public Relations

department we had at the time but my boss thought it would be a good way to put my skills to use – and he was smart enough to know I wasn't feeling particularly challenged – very busy, yes – but wanting more – so HE challenged me. He continued to raise the bar while also making it possible for me to have my cake and eat it too – that is, work flex time and be home with my kids.

*M*is for
*M*other

Rebecca L. Kopelman

Rebecca (Becky) has been a mother since 2011, when her son was born. Prior to motherhood, she had an eleven-year career (of which she is quite proud) as an Applications Scientist and Product Manager. Working for a manufacturer of scientific equipment sold internationally, she traveled extensively to provide customer support, customer education, problem solving and sales. She gave birth to her daughter in 2014 and continued her career in Product Management, part time, through 2015, at which time, she devoted herself full-time to motherhood.

Grateful to have the choice to be home with and raise her two young children she is excited to figure out what's next once they grow up a bit more and need her less.

While, at times, admittedly, she misses her career, she knows that for her, she would miss being present for her children's youth more. When combined with her husband, Roni's travel and therefore her need to be the flexible parent (think sick days, teacher development days, snow days, holidays and school breaks), staying at home with the children works out just right for their whole family right now!

Becky earned a BA in Biology from Wittenberg University and an integrated science and business MS in Biotechnology from Northwestern University. After beginning her career in Seattle as an Applications Scientist, she met and fell in love with Roni, got married and moved back to the Midwest and continued her career in Product Management until after the birth of their second child.

Becky is proud to be a mother but also proud to have a science background. And so, very grateful to have both parts of her in there.

I met Becky because my wise and cherished nephew, Roni, fell in love with her; then we all did. She is as beautiful on the inside as she is on the outside and has brought pure joy to our family.

Here are her answers to the questions:

Where were you born?
Maryland.

How would you describe your childhood environment?
I grew up in a warm and loving home with a mother who was a part
time nurse and a father who traveled often for his job as an agronomist,
an expert in the science of soil management and the production of field
crops. My mom was an active PTA member who made home cooked
meals, always offered support and made every birthday special for my
brothers and me. I was so lucky to grow up in a neighborhood where
my brothers and I felt safe, made friends, played outside and always
felt at home. My brothers were my best friends, and closest playmates
and I remember having a happy, fun and cozy childhood.

As a child, what did you hope to be when you grew up?
A science teacher.

**Did you know as a child that you would be engaged in your
chosen work?**
As a mother, yes - I hoped anyway! My science management work, no!

**Would you like to acknowledge one or more individuals who helped
you shape your behavior, beliefs and work habits while on your
early journey?**
My mother has helped shape me more than anyone else. She is the
most thoughtful person I know and she imparted her ways onto my
brothers and me – to show grace to those who need it, to love family
unconditionally, to stay true to your word and to embrace what is
instead of chasing or worrying about what could be.

**As a young girl what difficulties did you have to overcome to move
towards your dreams?**
My parents separated when I was thirteen and there was a lot of
emotional upheaval involved. My sense of self was rattled, but through
a strong relationship with my mother and brothers, I was able to move
forward to find peace with myself and later with my amazing husband.

Where were you educated/trained for your work?

As a mother, it is mostly on the job training, but I had an excellent role model in my own mother.

As a scientist, I received a BA in Biology from Wittenberg University and a MS in Biotechnology from Northwestern University which was a combined science/business program.

How much training did your work require?

As a mother, it is ongoing.

As a scientist, my most recent professional job was as a Product Manager for a science information company. This work required an advanced degree in science, as well as work-related marketing and product management experience.

Once you entered the workplace, as a young woman, what obstacles did you have to overcome?

My first job in the workplace was as an Applications Scientist. On a personal level, I moved far away from home to take my first job and had never lived on my own before, not to mention travel alone like I did for my job. I was initially intimidated by going out on my own! I also dealt with professional obstacles – competitive female coworkers, male peers and superiors who saw me as a young girl who wasn't always taken seriously.

As a woman, what challenges did you have to overcome?

As a mother, questioning myself; am I doing it right, am I doing enough? Personally, I sometimes struggle with the balance between motherhood and "me" hood.

As a scientist, similar to the above question, competitive female coworkers, male peers and superiors who saw me as a young and inexperienced girl who wasn't always taken seriously.

Are you satisfied with your chosen profession?

As a mother? Yes! I left my professional career in product management after the birth of my second child. My work environment was stressful and not family-friendly, so my husband and I made the decision for me

to stay home to raise our two children. While my days are long, loud and overstimulating, I have never felt so satisfied, like what I do every day, matters.

Being a mother is more exhausting and emotional than my "real" jobs ever were, but I also see my days an investment in my children's and our family's wellbeing and sense of security. I know I am lucky to have the choice to be with my kids and also to have the option to look for work again in the future when my children are in school all day and I have more time for me again. I also enjoy being able to cross things off our family's to-do list during the week so we can try to just enjoy more time as a family on weekends when my husband isn't working.

Describe a typical work-day from morning 'till night.
I wake up when my children do, around 6:45 a.m. If I am lucky, I can squeeze in a shower (sometimes at the cost of a mess down the hall), then the three of us head downstairs for breakfast. I make breakfast for both kids, fill up water bottles, make my son's lunch, put clean dishes away, help get the kids dressed and their teeth brushed and get them out the door for school. I make sure my son gets on the school bus and then drive my daughter to school, where she has preschool for two and a half hours. While she's at school I may shop for groceries, volunteer in one of my kids' classrooms, go to a doctor's appointment, clean our house, exercise or run an errand and then I head back to pick her up at 11:15 a.m.

We come home to eat lunch together and our afternoons are filled with things like ballet class, play dates, a project around home, errands or just playing together. I pick up my son from the bus stop around 4:00, so for the next hour or so I get him a snack, check his backpack and let him play and unwind until dinner. I usually make dinner for my kids around 5:15 p.m. After the dishes are clean, we play a bit more before heading upstairs for the beginning of long but unwinding bedtime routines. Once the kids are asleep – usually after 7:30 p.m., my husband and I cook our own dinner, finish cleaning up, fold laundry and tend to anything else that needs to be taken care of before the next day.

Are you preparing for a different career?
Not yet, but I am beginning to imagine what sort of career could allow me to use my pre-motherhood work experience without sacrificing the flexibility I need and want to be the primary caregiver of our children.

Have you continued your studies?
As a mother, every day presents new lessons.

As a scientist, not officially. I just stay up to date as much as I can through social media and networking with former coworkers and classmates.

What are your current goals?
My primary goal in life is to maintain contentment and balance for my family. Goals related to motherhood are so general yet so important, like raising kind, smart and happy children who know right from wrong and who have the tools they need to become good and successful adults.

As my children grow up, I hope to find a new identity for myself that can be in addition to being a scientist, mother and wife. I would love to find a hobby I enjoy and am good at, and to possibly find a way to work professionally without sacrificing the flexibility I want to be able to be there for my family.

Do you have a ten year plan?
I have a rough ten year plan; my children will be teenagers so I would love to be available to them through their teenage years, emotionally and logistically but I'd also love to have my own "thing" by that time, whether it's more involvement in their schools at a high level, a part or full time job, etc.

Where do you see yourself living in ten years?
Ideally, right where we are now! But anywhere my husband is content with his job is best for our family balance; I can mother anywhere.

Do you have a twenty year plan?
I'd like my husband to retire in twenty years.

Do you have a retirement plan?
My husband and I hope to be able to stop full time work, sell our
suburban house to buy a smaller condo in an area of the country we
love, travel and visit our kids often, wherever they end up.

How do you spend your leisure time?
I love taking pictures and organizing them, preparing healthy meals
for our family, watching Netflix with my husband and spending
time outside.

What frightens you?
Losing people I love. Cancer. Our current political situation where
everyone is so angry. Climate change.

What saddens you?
Same answers as above! Also, that dogs don't live as long as humans,
that some people are just plain mean and that my husband, kids and I
will die someday.

What pleases you?
So many things! Quality time as a family. Hearing my children play and
laugh together. Family tickle fights. Fresh air and time out in nature.
Teaching my children to love, be kind and respect science. Cooking and
eating delicious food. Taking neat pictures and reminiscing through old
photographs. Exploring new places, but also just being home.

What advice would you give your younger self?
To not always rush the stage I'm in and just enjoy it.

What advice would you give a young woman entering your field?
As for Motherhood – oh, wow! To try to not over-worry each decision
and step; breastfeeding vs. bottle, baby wearing vs. not, working
mother vs. stay at home mom…We're all the same; we just want the
best for our kids. I'd also tell her to remember that she is the only mom
her child has so there is no way for her to do wrong; she's what her
child knows and wants and loves.

As for Product Management in Science – to remember that her
education and experience is the same as any man's so she should
expect and demand to be treated the same way.

MY WORDS; MY VOICE

Becoming a mother, while it was something I always imagined for myself, it changed everything I had known about how to live my life. The days get long, overstimulating and exhausting, but at the end of each day, knowing my little ones are tucked safely into their beds and have one more day of memories behind them truly satisfies me. I take pictures of it all – something my mom did for me and for which I am so appreciative; almost as a way of preserving my children's childhood for them during the years they won't always remember.

I am so grateful to have the choice to take a break from my career to raise them. It's so much work and not for everyone but I love eating lunch with my daughter every day. I love being there for my son as he gets off the school bus. I love volunteering in their classrooms to get to know their teachers and peers and I love being able to watch them experience different sports, classes, activities, play date friendships, etc. I know they'll be "big kids" before I know it and our lives will continue to change, but I can only hope that my presence during their early years will help them to grow up feeling secure, supported and so very loved.

In the meantime, it is easy to lose a sense of who I was before my children were born, especially because even when I am not with them, a piece of my brain and heart always are. Now that I am in my early forties, I am trying to remember not only what's at the core of myself as a wife, mother, daughter, sister, friend, professional, but also just as me!

It's a struggle all women face, not just mothers, but I've found it especially hard to quiet the noise of two young children and a busy home to hone in on the really important things again. It sometimes feels selfish, but just like time away for date night with my husband keeps our family moving forward better, taking care of myself usually means making our family dynamically better too!

Luckily I have created a few small circles of friends who have made my life so much better. They are all moms who are going through the same joys and hard days, and being able to check in with them and experience this phase of life together has become so important to me.

I am trying to listen to more of "my" music again, read more about the things that interest me and not just my children, find new recipes to make, get outside more for quiet time in nature, carve out time for self-care when I can. It isn't easy, but I try to remember that a more peaceful me makes a much better mom and wife than an over-committed, stressed out version of myself. The older I get, the less I am caring about what I think I should be wearing or doing, who I think I should be spending my time with, what I worry I should pursue for future career work and caring more about just listening to myself to do more of what makes me happy. But being able to do that while also watching my children become their own people, learning what makes them tick, and being a big and active part of their childhoods is what makes being a mother the greatest job I could ever hope for. I am grateful for every day I have with them.

Connect with me on Instagram;
www.instagram.com/onceuponqueeneanne

*N*is for
urising Supervisor

Esther Thambidurai

Esther's nursing career spanned thirty-two years. Educated in India and Canada, Esther practiced nursing in Saskatchewan, Canada and New Jersey, United States. She took a ten year hiatus to raise her three children then began her career again in the New Jersey prison system at a Youth Correctional Facility. When the facility was privatized, she took a job as a nursing supervisor at a psychiatric hospital in New Jersey and worked there for fourteen years before she retired in 2008.

Esther was a neighbor when my husband and I lived in Florida. She and I were members of the theater club. Esther and my husband were members of the Bocci club; she, being the only woman in the group. She is sensitive, thoughtful and talented, a kind neighbor and delightful lady who bakes delicious muffins.

Here are her answers to the questions:

Where were you born?
I was born on or about August 31, 1940 in Hartpiplia, Madhya, Pradesh, India to a couple who were farmers. My mother passed away during childbirth. My father took me to an orphanage and at the age of nine months old, on May 15, 1941, I was adopted by a couple who wanted a girl.

How would you describe your childhood environment?
Normal and happy. I was adopted by my parents James and Helen Anukoolam. My adoptive father was the principal of a boy's high school and later became the Deputy Director of Education. My brother and I often accompanied our father as he inspected many schools in different provinces in the state of Madhyapradesh, which allowed us to travel extensively through central India.

My father was from South India and my mother from New Zealand. She came to India as a Nurse Missionary. My dad taught her the Indian language Tamil which was his mother tongue.

As a child, what did you hope to be when you grew up?
A teacher.

Did you know as a child that you would be engaged in your chosen work?
No.

Would you like to acknowledge one or more individuals who helped you shape your behavior, beliefs and work habits while on your early journey?
My dad, an aunt and several teachers in school helped shape my behavior and beliefs and work ethics while growing up. My dad encouraged me to go into Nursing. I was eager to go abroad.

As a young girl what difficulties did you have to overcome to move towards your dreams?
Applying for a job in a foreign country (Canada), leaving my dad, family and friends and my familiar surroundings. Also, traveling alone to a distant land.

Where were you educated/trained for your work?
I studied at the Canadian Mission Girls High School in Indore, Madhya Pradesh. I graduated from high school in 1958. I did one year of pre-university studies at the Women's Christian College Madras now known as Chennai in South India.

I then went to Nursing school at Vellore Christian Medical Hospital School of Nursing. After graduating in 1963 I worked in India until 1966. That year I got the opportunity to go to Regina Saskatchewan, Canada. I was assigned to the Operating Room. Since I enjoyed it, in 1968 I went to the Montreal General Hospital to do my post graduate studies in Operating Room Technique and Management. Following that course, I returned to Regina and worked there for another year.

In New Jersey, I started at the Youth Correctional Facility as a Staff Nurse in 1982. I got my Nursing Supervisor's title in 1985. I worked at this facility for fourteen years. I then went to work at a Psychiatric Hospital and worked there as a Nursing Supervisor until my retirement

eleven years later. In total, I worked for the state twenty-five years full time, one year part-time.

How much training did your work require?
Three years General Proficiency and one year Midwifery and Public Health, six months Operating Room Technique.

Once you entered the workplace, as a young woman, what obstacles did you have to overcome?
Learning a new language, Tamil, as I grew up speaking Hindi. When on Public Health trips to Villages, I had difficulty communicating with patients and their family.

As a woman, what challenges did you have to overcome?
Language was a barrier. India has fourteen major languages and many dialogues! When arriving and starting to work at the Regina General Hospital in Saskatchewan, I was apprehensive in the beginning as everything was different. I was asked to work in the Operating Room which I did not want to do. I ended up working there for two years!!

Are you satisfied with your chosen profession?
Yes, I am satisfied with my profession. Sometimes changes are hard to make, but that can be overcome.

Describe a typical work-day from morning 'till night.
As a nursing supervisor, the first thing I checked was that all staff were present and on time for work. I reviewed the shift change report, supervised the nursing staff's jobs, supervised the patients' meals on the unit and in the Dining Room. I attended weekly team meetings regarding patients' progress and discharge plans. I taught classes to new employees.

Are you preparing for a different career?
No, I retired from nursing.

Have you continued your studies?
No.

What are your current goals?
I would like to do some volunteer work at the library or in school.

Do you have a ten year plan?
Not really. I would like to travel.

Where do you see yourself living in ten years?
I don't know.

Do you have a twenty year plan?
No.

Do you have a retirement plan?
I am retired.

How do you spend your leisure time?
I have a daughter, two grandchildren, Asha and Devon, living in Delray Beach. I spend as much time as I can with the family. My other children are abroad; I have one grandchild in Italy who I unfortunately don't get to see enough. I enjoy knitting, crocheting, sewing and embroidery which is a great pastime for me. I hope to continue to take part in the theater group productions.

What frightens you?
The unknown future! The fear of not being able to take care of myself if I were to become ill.

What saddens you?
My life on earth is in its twilight zone! Health is an issue. Not having the strength and energy to do the things I used to enjoy.

What pleases you?
My family and friends. Meeting new people, socializing. Opportunities to help or do something nice for others. I've been living in Delray Beach, Florida for almost five years. During that time, I had the pleasure of meeting Beverly and her husband, Armand.

What advice would you give your younger self?
Be patient, work hard, pray and believe in yourself. Don't give up when things go wrong. Learn what you can when opportunity arises.

What advice would you give a young woman entering your field?
Look forward to a bright and rewarding career. Be prepared to work

hard. Be honest. Keep up with the modern technology within your profession.

MY WORDS; MY VOICE

Nursing is a wonderful career. Once you graduate from an institution and wish to further your education, there are many different branches in nursing you can specialize in. I am saddened to see that fewer and fewer nurses are doing real nursing, "Bedside."

The health system has changed tremendously. I am happy I was able to do hands on nursing during my career. There is a special bond between nurse and patient. They get to know and build their trust in you. I have memories of patients thanking me for taking care of them once they were better and ready to be discharged. My reply to them was "I just did my job!"

O is for
perations Manager

Diane Hofman-Seiple

Diane Hofman-Seiple was a results-driven professional within the International Transportation and Logistics Industry.

Her interest in the International Shipping business began during her summer vacations from college, when she secured a part time position with a freight forwarder.

Fascinated with the transportation industry, after graduation her goal was to work for two years before pursuing her longtime dream of becoming an attorney. The two years turned into thirty-eight years, where she held numerous positions as operations manager, senior manager, director, vice president, and rose to chief operating officer where in one international company she oversaw all U.S. operations. Throughout the years, Diane had the opportunity to travel extensively both domestically and internationally while meeting people from all walks of life all over the world.

Recently retired, Diane lives in Florida with her husband Jim and their two dogs. She enjoys reading, walking, gardening, water aerobics and Mah Jongg.

Diane is my cousin and we burst with pride at her accomplishments as she worked her way up to Chief Operating Officer.

Here are her answers to the questions:

Where were you born?
Queens, New York.

How would you describe your childhood environment?
A very comfortable and enjoyable environment which I shared with my older sister Barbara and our devoted and loving parents. Looking back now, I realize how fortunate and privileged I was to have the support and love of my family.

As a child, what did you hope to be when you grew up?
Not until I was a teen, did I consider law.

Did you know as a child that you would be engaged in your chosen work?
No.

Would you like to acknowledge one or more individuals who helped you shape your behavior, beliefs and work habits while on your early journey?
My mother was very instrumental in guiding and supporting me. Her encouragement helped shape my behavior and taught me how to be an independent woman.

As a young girl what difficulties did you have to overcome to move towards your dreams?
I struggled with my weight as a young girl as well as an adult. Although a huge challenge for me, I did not allow it to hold me back.

Where were you educated/trained for your work?
My undergraduate studies began in Queens, New York and were completed at Loyola University in Chicago. I majored in political science. My degree was totally different than my chosen profession.

I was taught my profession on the job by some of the finest mentors in the industry. There were also specific courses that I took for the movement of hazardous goods, DOT (Department of Transportation) rules and requirements as well as international finance.

How much training did your work require?
Many years of on the job training in different areas of the industry.

Once you entered the workplace, as a young woman, what obstacles did you have to overcome?
First, learning how to function in corporate America. Then, maneuvering through the many layers of politics.

As a woman, what challenges did you have to overcome?
The industry I chose was dominated by men particularly in upper management positions. I often felt that I had to consistently prove I was worthy of my position. Men were treated differently when I entered this profession. Today, the landscape is totally different, and there are many talented women in high-level transportation positions.

Are you satisfied with your chosen profession?
Overall, yes. It was always stimulating, challenging and often exciting. I had the opportunity to travel extensively and meet some wonderful and interesting people.

Describe a typical work-day from morning 'till night.
There was never a typical day. It was international logistics and every country we shipped into or from, had different requirements. Things moved quickly. You had to ensure local customs and regulations were met and adhered to. Every shipper was unique, having their own requirements that had to be met. Often, very challenging.

Are you preparing for a different career?
No.

Have you continued your studies?
No.

What are your current goals?
To enjoy a comfortable and healthy retirement with sufficient financial stability.

Do you have a ten year plan?
I do not have a ten year plan as a retired person. I hope that whatever the future holds for me, I will be in good health and have my spouse beside me.

Where do you see yourself living in ten years?
I am hoping Florida.

Do you have a twenty year plan?
No.

Do you have a retirement plan?
Yes. I am living it. To enjoy every day in good health. To share time with my family and friends and continue to have the ability to travel.

How do you spend your leisure time?
I enjoy reading (I belong to two book clubs), walking, playing Mah Jongg and gardening. I travel for pleasure. Now I do something I could never do with my decades long hectic schedule; I have lunch with friends.

What frightens you?
The future, health and finances.

What saddens you?
My immediate family is not local.

What pleases you?
Waking up in good health and having the ability to do whatever
I choose.

What advice would you give your younger self?
Enjoy your youth and follow your dreams.

What advice would you give a young woman entering your field?
International logistics is a fast-paced industry requiring
coordination and flexibility throughout the supply chain. It requires
customer service and attention to detail. One needs to react quickly to
on-going changes and daily challenges, while working with airlines,
steamship companies and trucking companies.

MY WORDS; MY VOICE
I was a well experienced very hard working and results driven industry
professional with a unique combination of comprehensive technical
expertise, managerial experience, profit and loss focus and business
leadership within the transportation and logistics industry.

I suggest you choose a career that challenges you. Enjoy what you do,
and it will never feel like work. When in management, guide and share
your knowledge. Find a balance between a career and a personal life.

Pat yourself on your back for your accomplishments.

Photo by: Javier Caballero Photography.

P is for
roperty Marketing Director

Alexandra Rich

Alexandra (Lexi) Rich has dedicated her career to marketing within the hospitality and real estate industries.

With several years of marketing experience behind her, she currently holds the position of Property Marketing Director for twenty-five multifamily apartment communities.

Her prior work experience was in property management at an HOA (Homeowners Association) in South Florida.

A New Jersey native, Miami transplant, Lexi earned her bachelor's degree in hospitality from the University of Delaware and her master's degree in mass communications from the University of Florida.

In addition to her being a well-respected property marketing professional, Lexi is a fine artist, a talent she utilizes when preparing marketing materials. When not working her 'day job', she runs her art business, Brushed in Bold, which specializes in fluid acrylic paintings and designs. Her pieces can be found on Etsy: **www.etsy.com/shop/brushedinbold**.

In her free time, Lexi can be found relaxing with her Pomeranian, Dolce, exploring a new Miami hotspot with her boyfriend, Zain, or planning her next trip. Her favorite countries so far have been Scotland and Israel. Eager to continue her travels, the question remains, "Where to next?"

I met Lexi when she was employed in property management at the community where my husband and I lived for a few years. She is bright, diplomatic and quite efficient. I had the pleasure of working with her when I published my novels and she guided me through the marketing process. Not only is she a dedicated professional, but a talented artist as well.

Here are her answers to the questions:

Where were you born?
Middletown, New Jersey.

How would you describe your childhood environment?
My childhood was mostly a very positive experience. I am an only child, so I was the center of my parents' attention including their focus on my studies. Growing up without siblings also allowed me to become quite independent. I was comfortable doing things alone, like finding ways to entertain myself at an early age.

As a child, what did you hope to be when you grew up?
It depended on the day! But as a young child, most often, a veterinarian. In high school and early college, however, I wanted to become a pastry chef.

Did you know as a child that you would be engaged in your chosen work?
Definitely not.

Would you like to acknowledge one or more individuals who helped you shape your behavior, beliefs and work habits while on your early journey?
My mom was wonderful at helping with school projects. She might not have always been able to help with a tough math problem, but she would sit for hours with me to perfect the science fair project or make sure I had the best costume for the history presentation.

As a young girl what difficulties did you have to overcome to move towards your dreams?
I was fortunate to have a family who could provide for my education and teachers who recommended early that I be placed in honors classes. The biggest challenge I faced as a child or young teen would have to have been being teased for being "nerdy." Looking back, though, I can't say I'd change anything about myself then – I'm now doing so much better than the bullies!

Where were you educated/trained for your work?
I received my bachelor's degree in Hotel, Restaurant & Institutional Management from the University of Delaware and my master's in Mass Communication from the University of Florida. My training for my current role as Property Marketing Director came mostly

from spending two years working property management at an HOA community here in South Florida. By learning about the operational aspects required to run a community, I am better able to market properties to prospective residents.

How much training did your work require?
My undergraduate program was intense. We had laboratory classes in real life hotels and restaurants to learn our trades and were required to complete nearly one thousand relevant work hours before graduating. My current role required several years of marketing experience, but I was given no specific training upon joining the team.

Once you entered the workplace, as a young woman, what obstacles did you have to overcome?
In some of my early positions, I found it difficult to be taken seriously due to my age. Sometimes, I felt like I was being judged by the "Millennial" stereotype.

As a woman, what challenges did you have to overcome?
I can't say that I've faced any challenges because I am a woman. I do find it difficult to ask for raises or promotions, but that could be attributed not just to my gender, but also my age or personality.

Are you satisfied with your chosen profession?
Yes! I feel like I've been able to combine the creative aspects of marketing with the service-oriented nature of hospitality to parlay into marketing and communications for real estate. I plan to stay in this industry.

Describe a typical work-day from morning 'till night.
As a Property Marketing Director, I am responsible for all marketing and communications for a portfolio of twenty-five multifamily apartment communities. In the morning, I check my email for any immediate fires. If required, I may update properties' websites and listing services like Apartments.com or Zillow.com with any new specials or pricing information.

Then, I likely work on designing flyers to promote one of our communities. I am also responsible for communicating information

about any new programs we're launching like new technology to help the leasing staff be more efficient or smart package lockers at the properties for residents to retrieve packages 24/7.

I spend a lot of my time acting as a project manager, coordinating conference calls, training sessions, email communications, etc., regarding these initiatives. Some of those vendors are on the West Coast, so I often cannot speak to them until the afternoon. I also like to spend a few minutes, typically at the end of the day, reading industry or world news.

Are you preparing for a different career?
No, but I believe we should always be learning. Lately, I've been delving into Adobe programs like InDesign and Photoshop so that I can improve my graphic design skills. This will enhance my marketability in the workplace because it means less money spent to outsource this work to a design firm.

Have you continued your studies?
Not formally.

What are your current goals?
Become more proficient at Adobe Creative Suite. Save enough money to buy an investment property. Continue traveling the world.

Do you have a ten year plan?
Not quite.

Where do you see yourself living in ten years?
I plan to remain in the Miami area.

Do you have a twenty year plan?
No, I don't.

Do you have a retirement plan?
I am saving for the future by investing a portion of my monthly income but don't have a formalized plan.

How do you spend your leisure time?
Planning my next trip, working on my art business, cooking or trying a

new restaurant with my boyfriend Zain and snuggling with our dogs.

What frightens you?
Not having enough money for retirement. Despite working hard and saving for the future, I will probably still struggle to build a cash reserve for retirement or will need to work for many more years than I want to. I am grateful I was fortunate to start my life with opportunities that others didn't have – but I wonder how those at my age who currently struggle to make ends meet will ever make it to sixty or eighty years of age.

What saddens you?
Leaving my pup home alone while I am at work all day.

What pleases you?
Being able to say that I've crafted a life I'm truly happy with.

What advice would you give your younger self?
Open up. It's entirely possible to be both professional in the workplace and friendly with your coworkers. It took me a while at my first job in Florida to let loose a little because I wanted to appear career-motivated and "serious."

What advice would you give a young woman entering your field?
Confidence is key in any industry, but especially in creative fields. Marketing requires thinking outside of the box and bucking the norm. It can sometimes be challenging to share these thoughts out loud. But if you think you have a brilliant idea, be sure to share it, and state it with conviction.

MY WORDS; MY VOICE
Introverts in the workplace. At my first marketing job in Florida, my boss would often tell me I was 'too shy' or 'too quiet.' I would often be compared to my 'bubbly' and 'outgoing' coworker, as if lacking these personality traits would cause me to fail at my job. I felt pressured to change innate aspects of my personality. She thought that pointing this out would force me out of my shell, but in actuality, it made me more

self-conscious and more nervous about speaking up.

As I got older, I learned that my introversion is a true strength, even within a marketing role. Because I'm introverted by nature, I'm an excellent listener and allow others to feel heard. Because I'm introverted, I keenly observe situations and get to the root of problems before figuring out the best plan to fix them. Because I'm introverted, when I speak, I make sure it matters.

Q is for
Quilter

Susan Mathes

Susan is a Quilter. She is involved in every facet of quilting from teaching, working quilting venues and of course creating her own magnificent masterpieces and award-winning quilts.

Susan's mother taught her sewing and instilled a respect and love for quilting and all fiber arts, such as dressmaking, heirloom sewing, machine and hand embroidery.

Susan is a semi-retired seventy-one year old currently living in Myrtle Beach, South Carolina with her husband of fifty-six years, Dave. They have three children, eight grandchildren and eight great grandchildren. While she has had many jobs in her lifetime, she has enjoyed the one she had for the past twenty years the most because it has allowed her to be fully involved in the sewing and quilting industry. She spends her free time in her sewing room constructing beautiful creations for those she loves.

Susan is a delightful neighbor, sweet and talented. She eagerly shared her life's journey. Walk in her shoes for a while as she navigated the chaos of the 1960s and '70s with an unplanned teenage pregnancy, early marriage and a young husband going off to fight in the Vietnam War. Through the challenges and triumphs, their love and commitment to each other continues to flourish. Susan and Dave have traveled the world and she provides us with an interesting description of their many journeys.

Here are her answers to the questions:

Where were you born?
Wilmington, Delaware.

How would you describe your childhood environment?
Normal middle class working parents. There were four kids. My sister, Cecelia (Cissy) is the oldest, I came two years later. My brother, Jimmy is two years younger than I and my youngest brother, Jeff, came four and a half years after Jimmy.

We lived in a small house that originally had only two bedrooms and one bathroom. My parents renovated the house to raise the roof to add a second story that included two bedrooms and a powder room. My sister and I shared one bedroom and my brothers shared the other. There was no central air, just a large window unit at the top of the stairs to cool both bedrooms. The second bedroom on the first floor became our TV room. Just large enough for one couch, the TV and my mom's sewing machine.

As kids we were involved in Brownies and Girl Scouts or Cub Scouts and Boy Scouts. My sister and I took dance lessons. We walked to school and played outside when we got home. We climbed trees and played kick the can, hide and seek, Simon says, and did all the other things children growing up in the '50s did.

My mother worked a job that got her home about the time we got home from school. My dad worked at the DuPont Plant in Deepwater, New Jersey and rode in a carpool that got him home at 4:45 p.m. It is funny that since we knew exactly when he would be coming in the door, we were putting dinner on the table just before he waked in. He would come in the door, give my mom a kiss hello and we sat down to dinner. We were done and out of the kitchen by 6 p.m.

It helped that the plant was only three miles from home, so his commute was only about ten minutes. Although my mom thinks we didn't have much, I don't ever remember feeling deprived of anything. We went on vacation to visit my mom's family in Ohio one to two times per year. Several times in the summer after church on Sunday mom would pack a picnic lunch and we would go to the lake for a day of swimming and cookout. As an adult I came to realize that is not how my parents would have liked to spend their day off, but they did it for us and it created so many wonderful memories.

As a child, what did you hope to be when you grew up?
A nurse.

Did you know as a child that you would be engaged in your chosen work?
No.

Would you like to acknowledge one or more individuals who helped you shape your behavior, beliefs and work habits while on your early journey?

My dad. He went to work every day, never taking time off except for vacations. He didn't take sick days that I recall. He always went to work on time. He went to college on the GI Bill after WWII and became a chemist for DuPont where he worked for 40 plus years. He was the only one of his family of nine children who went to college. My dad turned ninety-nine years old in February 2020 and is still sharp as a tack. He keeps up on all current events and is essentially the caregiver for my mom who just turned ninety-six in November 2019. My dad is my hero!

Also, my mom—she is the sewer and it is because of her that I became interested in sewing in general. She made our clothes when we were little. She also made doll clothes for us. She was always busy with her hands, either sewing, knitting or crafting in some way. I received my love of sewing and crafting from her.

As a young girl what difficulties did you have to overcome to move towards your dreams?

I never did become a nurse. After my sophomore year of high school, I got pregnant. I was fifteen years old. My boyfriend had just graduated from high school and joined the Navy. We were married in September 1964. I was fifteen and he was seventeen. Today we have been married fifty-six years, have three children, eight grandchildren and eight great grandchildren. Our story is not the norm for kids who marry so young. We are very happy and so fortunate in that we had such a loving family and such good role models. Needless to say, this did have an impact on the way my life would go.

Where were you educated/trained for your work?

My quilting work came about because I got a job in a store that sold sewing machines and fabric, mostly quilting cottons. I really had no formal training. It was on the job and listening to the owner who has become a dear friend during the past eighteen years I have known her.

How much training did your work require?
For the quilting, not much. I just followed pattern directions.

Once you entered the workplace, as a young woman, what obstacles did you have to overcome?
The challenges I had to overcome were as a result of my actions. When I became pregnant at fifteen, I met with the high school principal to request that I study at home in the fall. Once he knew the reason for my request, he was very helpful. I started being tutored in English and Spanish, took correspondence courses in typing and shorthand and tried studying history on my own. That lasted until Christmas vacation. I had my baby girl, Jennifer in March. Then in May I went to keypunch school. My mother had to drive me every day because the driving age in New Jersey was seventeen and I was still sixteen. After keypunch school, I went looking for a job and was turned down because I did not have a high school diploma.

So, in August I took the stated tests for an equivalency diploma. I needed sixteen credits and after my two years of school I had ten and a half credits, so I needed to take U. S. History 1 and 2, English 3 and 4 and two electives. I chose General Math and Business Math. Well, I passed both English, failed both History, passed General Math and failed Business Math. So on to night school in the fall to take History.

While there the teacher asked why I didn't take the GED. I told her I couldn't because I was only sixteen. They wanted to encourage young people to go back to school, so the minimum age for GED at that time, was twenty-one. The advice I received was that if I had a letter from my employer stating that I needed my GED in order to keep my job, the age requirement would be waived. Piece of cake. I was working for my cousin in his doughnut shop, so I obtained the required letter. In January of 1966 I took the five-part GED exam.

While I waited for the results my Navy husband and I and our baby daughter went to Florida to live as a family for the first time before he left on a carrier for a mission to Vietnam.

We lived in a tiny apartment. There were three or four of Dave's buddies who lived on the ship and came by every weekend to our place. I did their laundry and they in turn bought food which I cooked and that's how we survived.

I got my GED results and passed. I had a high enough score that I could have gone to college, but I was focused on spending time with my husband before he shipped out.

When he left for Vietnam, I went home with my daughter Jennifer and moved in with my mom and dad while my husband Dave completed his three-year enlistment in the Navy. I was never alone, surrounded by family. I got a job as a Keypunch Operator right across the bridge from my parent's home. I received $123 per month and Dave received $15 a month from the Navy.

As a woman, what challenges did you have to overcome?
I don't recall having obstacles to overcome. I guess I was pretty fortunate in that respect. Once Dave came home, we settled in and had a great life. There was one time in 2013, when Dave had to travel for business to Bangkok and the government was overthrown. He was unable to come home; I had planned to join him, but my trip was cancelled because of the unrest. I was anxious about his safety. His company eventually arranged for him to leave on a moment's notice.

Are you satisfied with your chosen profession?
Over the years, I've had several careers. Once my husband got out of the Navy, he got into the computer field and we moved quite a bit. So, I got jobs that I could do wherever we were. For the past several years I have worked part time in a sewing and quilting store as a sales associate and teacher. For the past 20 plus years, I have worked for Original Sewing and Quilt Expo (www.sewingexpo.com,) as a paid contractor. They produce the largest multimedia sewing and quilting expo in the United States. This expo includes sewing, quilting, dressmaking, heirloom sewing, machine and hand embroidery and many other fiber arts as well as beautiful displays to see and lots of classes to take. Our vendor hall is well varied in scope. They produce

eight shows a year and growing. I love the variety of amazing people I get to meet and the inspiration of all these talented people.

Describe a typical work-day from morning 'till night.
It depends on which hat I am wearing. While working the expo, during set up we start at 8 a.m. My job is to set up everything in the registration area. This includes two computers and printers, putting all of the signage on signboards and distributing them around the site on easels, getting all the paperwork ready for show days, counting all the inventory we sell at the registration desk, putting up a display of our logo items for sale. It takes a day and a half to accomplish all of this. On show days our day starts at 7:30 a.m. and ends when the last class starts in the evening, usually 6:30 p.m. During the show, I manage the registration staff, sell class and admission tickets, reprint tickets for our clients who need it and am the liaison between management and staff. I wear a radio and earpiece to be in contact with them at all times.

On Saturday, after the show, I pack all the registration area up and supervise the labor stacking of our pallets before finishing for the night, could be 7:30 p.m. or later. Then I go back to my room at the hotel, pack my suitcase and leave for home in the morning.

When I am not travelling or working at the store, I spend time in my sewing room doing what I love to do. We have recently moved from Maryland to South Carolina so I won't be working at the store on a regular basis but will from time to time when I am in Maryland. I am seventy-one years old now and thinking of slowing down just a little. I need plenty of time to use up all of the fabric that we moved down here with us.

Are you preparing for a different career?
No.

Have you continued your studies?
No.

What are your current goals?
Settling into my new home and quilting.

Do you have a ten year plan?
No.

Where do you see yourself living in ten years?
Myrtle Beach, South Carolina.

Do you have a twenty year plan?
No.

Do you have a retirement plan?
To enjoy my life with my husband as long as God allows.

How do you spend your leisure time?
Quilting, sewing, visiting friends, watching television with
my husband.

What frightens you?
I'm not easily frightened. But I am fearful for our young people in this
rampant time of drug problems. We didn't have that to deal with when
I was young, or my kids were growing up. I am afraid for my great
grandchildren.

What saddens you?
Thoughts of life without my parents. They have been such an
inspiration to me and the best role models. Asked what the secret to a
long and happy marriage is my mom replies every time. "Good Living
and Good Loving."

What pleases you?
Spending time with my family. Catching up with everyone and seeing
all the little ones.

What advice would you give your younger self?
Study hard. Work hard. Play hard. Become a well-balanced individual.

What advice would you give a young woman entering your field?
Enjoy yourself, experiment, use your imagination to create. If you can
imagine it, you can create it.

MY WORDS; MY VOICE

My favorite things I have made are also the most challenging things.
I have made a christening gown for the first born of each of my three
children. The last one though, was the most difficult. It consists of eight
lace shaped panels and eight fabric panels with lace and embroidery. It
took fourteen yards of lace and four and one half hours to sew the lace
around the bottom of the gown. My youngest grandson wore it. And a
friend borrowed it three times for use by three of his granddaughters. It
is a beautiful gown.

The next thing I enjoyed designing and making is a Quilt of Valor
for my dad. It is made up of six inch star blocks with two pictures I
digitized and stitched on my home embroidery machine. I copied the
two planes my dad flew on during WWII onto fabric and included
them in the quilt. I then embroidered some wording around the edges.
The label is embroidered with his service record of achievements
and awards presented. It was presented to him at a Quilt of Valor
presentation at one of the Sewing and Quilting Expos where I work.
As a surprise my husband was presented with a Quilt of Valor made
by me at this presentation as well. I am very proud of both of them and
their service to our country. My husband is the only one among my
brothers and brothers-in-law who served.

When I started quilting, I used simple shapes and kept it to squares. As
I grew in my ability and confidence, I found I like to use triangles and
more complicated patterns. I have quilt designing software that I used
to design dad's quilt as well as wedding quilts for my grandsons. It is a
useful tool to see how I like the pattern in the colors I have chosen.

I used to sew clothes for my children when they were young. It was
a lot of fun to see your children wearing something no one else had. I
sometimes dressed my girls alike and made something similar for me.
I made doll clothes like my mom. I will be forever grateful to my mom
for instilling in me the love of sewing and creating no matter what the
project is.

I would be remiss if I did not acknowledge my husband for the

wonderful life he has given me. Because of his career we have been very fortunate to have travelled all over the world.

In the early years we lived in several places in the United States: New Jersey, Minnesota, Maryland, North Carolina, Florida and now we have settled in South Carolina for our retirement years. During the height of his career in the IT field, we had the opportunity to visit many places abroad such as Munich, Germany, Vienna, Austria, London and several places around London, England. While working in London, Dave had to make several business trips to Dublin, Ireland and on one occasion, we met up with friends who were on vacation, so we took a few days to go with them. We drove through Ireland and visited several castles and continued on to Scotland for a couple of days. Touring with friends was priceless. The Vienna, Austria visit was due to him qualifying for an awards trip with his company. Part of the awards program included a masquerade ball in the town hall and a formal dinner where the special entertainment was the Vienna Boys Choir. It was magnificent.

Dave worked in Sydney, Australia for six months in 1999 and we lived in the heart of the Central Business District in an apartment that overlooked Darling Harbor with views of the Harbor Bridge and the Opera House. On our final trip home, when leaving Sydney, Dave and I and the couple we were there with planned an awesome three week trip with private sightseeing tours at each stop continuing around the world. Our first stop was Bangkok, Thailand where we saw the great golden Buddha.

Then on to Rome, Italy. There we went to the Vatican Museum and the Sistine Chapel, St Peter's Basilica, the Coliseum and the Catacombs among other sights. Next stop was Egypt. We went to Cairo and saw the Pyramids, the Sphinx and the Museum which had the artifacts of King Tut. We went to the Valley of the Kings and saw the tombs of King Tut and Nefertiti. It was an amazing experience and one that I will forever cherish.

After Sydney, Dave was sent to London and we stayed at the Intercontinental Hotel in Mayfair. While Dave worked, I went

sightseeing, walking all over London. It was quite the adventure. From London, Dave was sent to Stockholm, Sweden. Although I did not go there with him, I did visit once, and the city was remarkable.

After Stockholm, we were stateside for a while. Then Dave was assigned to an account in Bangkok, Thailand. I think he really enjoyed Bangkok. I did not get to visit here. Although I did have a trip planned and had my ticket in hand, there was an uprising and the government was overthrown. United Airlines called and cancelled my plans. It was difficult to even get the Americans out of the country. They had to be ready on a moment's notice once plans were in place. A little bit scary on this end, but Dave never felt he was in danger. We have been stateside since then.

But even before his overseas assignments we had the opportunity to go on a wonderful vacation with neighbors and others on a special trip to Australia and New Zealand. It was our first time to visit Sydney not knowing we would have the opportunity to live there for a short period several years later. We also got to visit Melbourne, Cannes and the Great Barrier Reef, the Outback and Ayers Rock and the Blue Mountains. We visited a sanctuary for penguins and got to see them as they returned from the sea on this particular day. It was an amazing sight. It is a beautiful country and if you ever have the chance to visit, you should.

From Australia we went to New Zealand. We stayed on a sheep farm for a night. We visited Christchurch and Auckland. We visited the Antarctic Museum and the Hot Sulphur Springs. Then we went to Fiji for a few days of relaxation before returning home. A few years later, we got the opportunity to accompany my parents on a trip to Europe as part of a tour. We first landed in Amsterdam and visited Anne Frank's house and some diamond brokers. I don't recall the order of our trip, but I do remember the cities we visited. We went to Paris and saw the *Les Folies Bergere*, the Eiffel Tower, the Louvre, the Palais des Tuileries and many more sites. We went to Monaco and Monte Carlo. My parents were a little unnerved when we saw topless sunbathers at the

rooftop pool of our hotel.

We went to Frankfurt and Cologne in Germany. Seeing all those castles still standing was amazing. We visited Switzerland, Zurich and Lucerne. We visited Italy, Rome, Pisa, Florence and Venice. We went to London and also visited Bath which still has Roman baths to see. We saw Stonehenge. Most people don't realize that the Roman Empire extended all the way to England. Being on a tour with my parents was so much fun and a memory to have forever. I have truly been blessed with a lifetime of experiences. Some of the people we have met along the way are still in our lives and I am proud to call them our friends.

If you are interested in any of my work, email me **sumathes48@gmail.com.**

Officiating at the wedding of Bev and Armand Gandara, 1981.

R is for
abbi

Helene Ferris

Rabbi Ferris is the first, second-career female rabbi in Judaism.
Formerly a school teacher and stay at home wife and mother to three
children, Helene began her studies at the age of thirty-nine and five
years later was ordained by the Reform Jewish seminary Hebrew
Union College-Jewish Institute of Religion in 1981. She worked as an
assistant then as an associate rabbi for ten years and senior rabbi for
fifteen years.

Among her many accomplishments, she has served as:

- The first woman appointed to the Rabbinic Board of Overseers of
 HUC-JIR (Hebrew Union College-Jewish Institute of Religion.)
- First woman on the governing board of The New York Board of
 Rabbis.
- Vice President of the New York Association of Reform Rabbis.

Besides ministering to her congregants for all their life cycle events, her
communal outreach activities include:

- Creating a shelter for the homeless in the synagogue which
 provided hot meals, showers and beds for ten adults, four nights
 weekly, supported by volunteers.
- Bringing Project Momentum to the synagogue to assist persons
 with AIDS by providing meals, clothing, counseling and support
 for them and their families.
- Organizing a conference on lesbian and gay Jews in New York
 City in 1986 and again in 2002 in Westchester, New York. In
 1989 she presided over her first of many same-gender wedding
 ceremonies.
- Serving as a prison chaplain at a women's prison in New York and
 addressed the problem of sexual abuse in a Letter to the Editor
 of *The New York Times* titled Female Prisoners and #MeToo which
 was published in 2018.

- Offering faith leadership reflection at a retreat supporting reentry for the formerly incarcerated at the Interfaith Center of New York.

- Serving as a volunteer chaplain at Calvary Hospital.

- Publishing a Sabbath Service for Holocaust Memorial Day by The National Conference of Christians and Jews.

- Participating in the Interfaith Center of New York Food drives.

- Serving as a rabbi to Holocaust survivors.

- Helping to prepare a prayer service and read from the Torah with over seventy other Jewish women at the Western Wall in Israel on December 1, 1988, an historic event when for the first time Jewish women prayed out loud, wearing tallitot (prayer shawls). She continues to support their struggle to this day.

She has worked with and on behalf of children, teens and seniors as well as the poor, sick and dying. She has clothed, fed and guided those in need of all faiths. She is simply, an inspiration.

My husband, Armand and I had the honor of having Rabbi Ferris preside over our wedding in Manhattan in 1981.

Here are her answers to the questions:

Where were you born?
New York City.

How would you describe your childhood environment?
Confusing. I was an only child. My mother had been married before and divorced, unusual in those days for a Jewish woman. She gave up her first child, a boy. She was a good and kind woman but unprepared emotionally to have attachment and distanced herself from me for fear of losing me. She was sensitive, the kind of woman who cried at supermarket openings.

I was bewildered by my mother's behavior until I was fifteen and she told me her story. What does a fifteen year old know about giving up a child? I remember thinking, she gave up a child and now has me. I slowly began to understand her.

She was very good to my father's family, welcoming into our home relatives in need.

When I was about eight to ten years old, she took in my uncle, a self-hating Jew. He was a physician and returned from World War II scarred emotionally from working in hospital tents with bombs dropping twenty feet away from him during the London Blitz. He suffered from nightmares. My mom catered to him. While he stayed with us, he had several Christian girlfriends visit; the bigger the cross, the more he liked them.

He made a lot of money performing abortions. Our religion teaches dedication to the concept of justice. We are taught this is an ideal and an obligation, not just good behavior. So, the question is do we do the right thing for the wrong reason or the wrong thing for the right reason? Always pursue justice, double justice, do the right thing for the right reason.

He moved to North Carolina for a job and was denied membership in a particular club because of his faith. He never married. When my mother became ill and had half her face cut away from cancer of the jaw, he never came to visit her, nor acknowledged my being a rabbi. I couldn't forgive him.

My attachment was to my father. We didn't go to services a lot. but when we did, it was comforting for me. I didn't ask a lot of Jewish questions. He knew a lot; he gave me answers about life.

My father was the comforter, the one who was there when I couldn't understand what the hell was going on with my mother's behavior. She never went to the synagogue.

It was a time I believe that made me try so much harder to be perfect. In my day we were told "Be good little girls, don't rock the boat, be perfect." We weren't and we shouldn't have been. It took me a long time to figure that out.

For a time, my great grandmother born 1850 in Germany lived with us. She came here as a child of ten and lived to 104. She was hard of

hearing but if you spoke loud enough, you could have memorable conversations. She claimed that she was in New York City watching a parade and saw President Lincoln. She was spiritual and thanked God daily. She sat in a wheelchair and prayed most of the day.

She was so upbeat, so willing to tell me how great I was. She died when I was seventeen. My friends adored her. We were all positively influenced by her.

There was a black woman who became part of our family. I called her Diney. She was like a nanny to me. She couldn't have children. With my mother not always around, she was the one with me during my disappointments. She was spiritual and involved in her church. She and my great grandmother nourished my spiritual appetite.

As a child, what did you hope to be when you grew up?
I was born in 1937 and grew up in the 1940s and 1950s. I don't remember what I wanted to be. I never thought about it early on. Later on, I knew I wanted to be a professional and was inclined towards more of the humanities than anything to do with science or math. There were no women rabbis–that's for sure. I was the first woman in my family to graduate from college.

Did you know as a child that you would be engaged in your chosen work?
No. My father was a learned man, one of five or six brothers, he, being the third born. According to his parents' wishes, the first boy was to become a doctor, he did. The second boy was to become a dentist, he did. The third boy, my father was to become a rabbi. He informed his parents that he did not want to be a rabbi, but a dentist. They said, fine, earn your own way through school and he did, by tutoring in Hebrew School. He became a dentist. I would like to think that I became the rabbi my grandparents wanted my father to be.

I do remember that when my father's family would gather for Passover, I was upset because I didn't understand what was going on between the reading of Hebrew and the chanting. I remember thinking,

one day I'm going to learn this.

Would you like to acknowledge one or more individuals who helped you shape your behavior, beliefs and work habits while on your early journey?

Negatively, my mother influenced me. She was stern with me and free with her hands. I remember an incident when I was married, and she slapped me across the face for saying something she didn't like. What had I done wrong that she treated me so poorly? I strived to be perfect. After a while, I understood her.

She lived with me as she neared death from cancer of the jaw, which disfigured her. She was barely 80 pounds and said to me. "Why am I being punished like this?" A visiting cousin reminded her she gave up a child. After I understood what she went through, by tradition, I forgave her and stopped blaming myself for what I may have done wrong. Judaism is a religion that holds the promise of forgiveness, if asked. She never asked for my forgiveness, but I gave it anyway.

Positively, my great grandmother. She was nurturing and giving, in spite of her disabilities.

My nanny who spent a lot of time with me, so accepting and so considerate. She encouraged my spiritual side. My husband and I were invited to her church to sing. I was already a rabbi when she died; I officiated at her funeral.

My husband got me through the beginning period of my rabbinate. He was the most liberated pro-feminist guy I knew. He changed diapers, cleaned the dishes, served the food, cleared the table; he was awesome. My friends' husbands hated him. When it was time for me to go to Jerusalem for my first year of study, he would be asked why he would allow me to go. He said, "If I was appointed to travel, would you ask her if she would allow me to go?"

My Israeli friend who helped me take care of my children that year in Jerusalem while I studied. She was an art student who came to study in Brooklyn. We are friends to this day.

As a young girl what difficulties did you have to overcome to move towards your dreams?
Aside from my relationship with my mother, I had no difficulties.
I received my BA from Barnard College and my master's, from Columbia. I started teaching 1959. I met my husband in Teachers College. We married in 1960 and I continued to teach until I became pregnant in 1963. We had a charmed life; and were married fifty-six years before he died.

Where were you educated/trained for your work?
In 1972, I read an article in the *New York Times* about the first woman rabbi ordained by the Reform Movement. I was inspired and believed I could become a rabbi as well. I waited three years until my youngest went to school full-time. With support from my husband and my rabbi I studied for the GREs (Graduate Record Examination, a standardized exam required for admission to graduate programs globally) and I was accepted into the program. I spent one year in Israel and four years in New York City at the Reform Jewish Seminary. The training is on the job every day.

How much training did your work require?
A total of five years including student jobs and life experiences!

Once you entered the workplace, as a young woman, what obstacles did you have to overcome?
I was forty-four when I became a rabbi and fought for acceptance and respect from congregants and male rabbis. Bosses who overloaded me with work, so they could focus on their celebrity status. Male rabbis in high positions, whose hands traveled to the wrong places. I felt I was being tested.

I don't judge but understand women who have advanced their career by being "extra nice." I was not.

As a woman, what challenges did you have to overcome?
Ageism and sexism. Those who didn't "get it;" who gossiped about why I was suddenly studying for the rabbinate. They said everything from my marriage was going sour and accused me of running away to I

was a spoiled rich lady, acting on a whim.

I had difficulties when I went to rabbinical school at the age of thirty-nine and attended school with twenty year-olds. It was a challenge for me to pack up our three children and move to Israel while I completed my first year of study. My husband stayed home to work. I missed him so much, even though he managed to visit three times during the year.

With three kids ages twelve, nine and seven and four suitcases, I arrived in Israel overnight. We didn't have a place to stay because the administration refused to cosign a lease to rent an apartment for us because no one thought I was serious and that I would drop out. The dean of the school greeted me with "Oh you're that crazy woman we heard about."

We stayed a few nights at a dinky hotel. We lived in four different places because of the attitude of the administration. When the president of the seminary would visit from the United States from time to time he looked aside when he saw me. My young classmates, however, were nice to me.

I studied hard, mostly while the children slept. I got through the year and earned The Most Improved Student Award and eventually the respect of the teachers who collectively said, "Now, we know you are serious." I returned to New York and completed four more years of study. At the end of five years, before my ordination, the president of the seminary told me "You taught the college more than the college taught you." A proud moment for me and my family.

As an assistant, then an associate rabbi, I was made aware I was not in line to succeed the senior rabbi, a dynamic speaker and radio and television personality more interested in maintaining his image than being involved with the congregants or the programs we had. I did not receive the respect I earned nor the support for many of the programs I oversaw, which I deserved.

After ten years, there was a meeting of the all-male board of directors and a decision was made to either let me go or allow me to remain for a

while as an assistant rabbi. Associate, assistant, they both start with "ASS."

For the first time I understood the politics and power of male egos. Something went off in my head. I thought I had done something wrong. I cried; it was very painful for me. I had strong support from the synagogue members but could not compete with the power that ruled the board. I moved forward knowing I could use that horrible experience to help other people.

Years later I was asked to return and speak at the one hundredth anniversary of the synagogue. I was told "We made a mistake." I knew they did, but it was good to hear.

I became the senior rabbi at another synagogue, and it was an adjustment for me as well as the members of the congregation. While I was treated with respect, they never had a woman rabbi before; it made the men uneasy. They complained about too much feminist stuff. I jumped in too quickly. I could have been more subtle; it was a learning experience for all of us. I remained there for fifteen years. It was a happy and fulfilling time after all.

I was almost seventy when I retired. I remain close to my successor and my congregation.

Are you satisfied with your chosen profession?
Yes. I am proud of my work. I learned so much and feel fulfilled.

Describe a typical work-day from morning 'till night.
There were no days off. I prepared for services, taught children and adults and attended meetings with staff and various committees representing the many programs serving our congregation.

I counseled individuals and couples for wedding plans or problems and worked with congregants to help navigate life events like bar and bat mitzvahs, births and deaths or everyday problems.

Outside the synagogue I attended interfaith meetings regarding the topics of the day and our outreach to the community such as food

banks, clothing drives, AIDS. I visited hospitals and when possible went anywhere my presence was requested.

Are you preparing for a different career?
No. But I will continue volunteering. I currently work with a senior group and have become a conversation partner for foreign students at the local community college. I am training to help women who live in a shelter. I would like to help people and to make the world a better place – not travel a lot. My time is better spent locally.

Have you continued your studies?
I learn every day just by living.

What are your current goals?
To continue volunteering wherever I am needed but be free enough to say I can't come in today.

Do you have a ten year plan?
To continue what I am doing.

Where do you see yourself living in ten years?
In New York.

Do you have a twenty year plan?
Living in New York, long-term care would be fine.

Do you have a retirement plan?
I'm not "retired," I'm "redirected" to allow for the things I love to do.

How do you spend your leisure time?
I play tennis three times a week, visit my children in California, and travel to Israel once a year. I've lived in Westchester most of my life, so I have many friends from grade school through college; we do lunch. I read a lot and play with my computer. I do not play cards, nor Mah Jongg.

What frightens you?
Concerns about my age, how long I have, how the end will be. Because God has been good to me, I don't know the future but I feel everything will be okay. My husband collapsed at a friend's dinner party. That was

it. No suffering for him. I would like that end.

A year ago, my children visited. I made a list of everything they have to do when I die. I went through insurance, funeral arrangements, phone numbers of people to get in touch with, computer passwords. I tried to make it easy. Everything is set. I'm looking at all my books in my study and I'm thinking that will be the hardest thing for them.

What saddens you?
The world in general. How people treat each other, how there's so much greed, so much hate and I just wish I could do something, wave a wand and make this world the way it should be. I listen to the news and say "Oh my God! How could people do that?"

Trump and the people who surround him.

What pleases you?
I believe there are more good people in this world than there are bad, I feel that it is going to come out alright. I have faith in the good people. Believing in the good. We have to do something about it. I want to do something good to my last breath. I think good people will win out in the end. I've been accused of viewing life through rose colored glasses. Deep down you have to believe it even if you're not around to see it.

What advice would you give your younger self?
Not to take life so seriously, not to take everything that happens, as always being your fault.

What advice would you give a young woman entering your field?
Take credit for what you do. Do not hide your light under a bushel. Don't say you're sorry so much. Women are always saying "I'm sorry." Blow your own horn when it's proper to do so. Be forthright in answering critics and don't blame yourself for things that went wrong in your business or profession or whatever; it is not always your fault.

Have confidence in yourself, you are special, you have special talents, use what's in your gut and do what your gut tells you to do. People look at accomplishments. What's an accomplishment? Is it headline worthy? God doesn't expect you to be Moses; God expects you to be the best that you can be.

MY WORDS; MY VOICE

Don't be afraid to fail, to try things. If something fails don't blame yourself because we're all imperfect. Don't give up. We women still have a lot to learn. We're learning it now and there are extremes in the women's movement I wouldn't follow. Try and do something until your last breath to help someone, some group, something that can make you feel worthwhile.

Photo by Michael Kaiser

On site at an acid plant.

S is for *Structural Engineer*

Brooke Guzar

As a structural engineer, Brooke works directly with architects who produce plans of what homes, commercial buildings, bridges, and other structures will look like and she designs the bones inside to stabilize them. She is motivated and inspired by the responsibility for public safety as well as creating moving spaces.

With over ten years of experience, Brooke works for a boutique structural engineering firm based in Toronto, Ontario, Canada providing engineering services to architects, developers and building owners. As a consultant, Brooke has the opportunity to work with junior engineers and university students. For the past two years, she has been designing unique custom homes.

Educated at McMaster University for Civil Engineering, she entered a field where there were very few women engineers and while she is a well-respected member of the community, from time to time she meets the challenge for acceptance as a woman engineer, particularly when working on a construction site with builders.

She feels most alive when discussing something she is passionate or knowledgeable about such as motorcycles, technology or structures. She always has a book with her in attempts to satisfy her curiosity. She can often be found wandering around and observing the built world.

Recently, Brooke has appeared on a television program called *Secret Nazi Bases* (in some countries *Secret Nazi Ruins*) discussing structures built during World War II. She also had a brief spot discussing viscous dampers on the show *A World Without NASA*.

My husband, Armand and I were watching the History Channel regarding the Secret Nazi Bases and were impressed by Brooke's knowledge and expertise as a Structural Engineer. She radiates a bright light of intelligence and strength which was evident in her television appearance. Her journey is inspiring and hopefully Brooke's story will encourage young women to enter into the STEM fields (science, technology, engineering and mathematics).

Here are her answers to the questions:

Where were you born?
I was born in Hamilton, Ontario, Canada.

How would you describe your childhood environment?
My childhood environment fostered curiosity, exploration and independence. My parents, my sister, our two wiener dogs and I spent summers on a boat travelling around the Great Lakes. I spent my days reading, swimming and exploring nature with a pocket-knife strapped to my belt, a fishing rod always handy and a well-indulged sense of wonder.

As a child, what did you hope to be when you grew up?
I don't recall having a specific career in mind, but I dreamed of taking things apart and putting them back together or building something new. I could usually be found inventing and testing things. The loudest message I received from my parents was the need to grow up and get a "good" job in order to be financially independent so that I could make whatever choices were authentic to me. Engineering was one of the "good" jobs according to my family unit.

Did you know as a child that you would be engaged in your chosen work?
Further into my teenage years I knew engineering was likely the appropriate path for me. I excelled at math and appreciated the quest for truth and understanding in science. Engineering would allow me to exercise my talent for math and perhaps satisfy my curiosity about how things worked.

Would you like to acknowledge one or more individuals who helped you shape your behavior, beliefs and work habits while on your early journey?
I find myself perpetually grateful for my parents who recognized a deep curiosity in me. They enabled this in any way they could and encouraged me to ask questions, contemplate observations and ideas and explore without boundaries. They instilled values such as respect, resilience, compassion and discipline which I feel are foundational to

my success as a human. I believe my strong work ethic and discipline comes from both of their examples. My grandmothers on both my mom and dad's sides were radical women in their younger years and encouraged a similar fire in me.

As a young girl what difficulties did you have to overcome to move towards your dreams?

Finding balance was challenging for me. I felt a pull towards social endeavors such as sports and friendships. I felt the pressure of time and decision making and was concerned about making the "wrong" decision. I felt heavy as well as inspired with the idea that I could do anything I wanted but I couldn't do everything. I think my most significant element to overcome was my own self-doubt and concern that any choice I made could lead to an unsatisfying life and that that path, once chosen, was the only one forever.

Where were you educated/trained for your work?

I attended McMaster University for Civil Engineering with a focus on the structural and geotechnical stream.

How much training did your work require?

Formal undergraduate education was a four year degree. I did mine in five years as I took a sixteen month co-op position. However, I still spend some of my weekends and evenings reading textbooks and feel I haven't even scratched the surface of technical structural design.

Once you entered the workplace, as a young woman, what obstacles did you have to overcome?

My first engineering job landed me at a small company (forty people) in which 90% of the staff were men and there was not a single female engineer. I had received the message that women in engineering were sparse, so this was not a surprise to me. Being a small company, I was thrown into many different roles and subjected to "trial by fire."

The structural team was welcoming, and the manager quickly took to mentoring me. Around me people were making decisions and articulating structural solutions with ease and confidence, while I struggled to find my voice. My internal voice was my biggest critic

and I had to battle feelings of inadequacy and incompetency, despite receiving excellent feedback on my performance from my peers and managers.

To overcome those feelings, I developed a mentality that it is okay to ask questions and admit I don't know the answer yet. I still often find myself arguing with the voice in my head, but I now have a better toolkit to resolve it and alter the tone and content of the voice by relying on discipline, self-efficacy and resilience to continue moving forward with impact and positive contributions.

I honed in on what I was good at and leveraged it. My ability to quickly connect with people provided a sense of security and opened avenues to ask questions and test out potential solutions.

As a woman, what challenges did you have to overcome?
One of the main challenges I had and still have to overcome, and combat is the idea that as a woman in engineering you show up at implicit deficit relative to your male counterparts. Typically, it feels as though I have to say something smart that will allow me to first be accepted at the table. Then I must continue saying smart things to be an option for consultation. This doesn't appear to be the case for male coworkers – they are already accepted as a proven resource.

This isn't always the case, but it can be particularly evident when working on a construction site with builders. It is frustrating and I combat it by talking to peers and young team members about it. I do my best to enable and encourage young women to attend meetings, rely on their structural knowledge and observe and challenge interpersonal dynamics. I believe project success is dependent on all disciplines and people involved and collaboration is at the heart of that success. I now know I have value to add and don't shy away from contributing. I have been practicing for over ten years now and still feel green and occasionally struggle with imposter syndrome.

Author's Note:
The term Imposter Syndrome, first used in the 1970s was attributed to

extremely intelligent, successful women who felt insecure about their
high achievement.

Are you satisfied with your chosen profession?
Engineering is a broad field and there are several facets in which
you can find yourself. It is vast and amazing. As a consultant I have
demolished and designed bridges, managed projects ranging from
bite-sized to multiyear endeavors, commissioned a multimillion
state-of-the-art booster station pump house, designed breathless fancy
mountain homes, travelled several kilometers underground, facilitated
meetings, managed teams, pulled "all-nighters," discovered machines
and methods I had no idea existed, and made lifelong friends who
share a similar sense of curiosity and admiration for the built world. I
am inspired most days and humbled by our duty to protect the public
by making sure appropriate safety measures are in place. It is very
satisfying to do a bunch of math, create documents that tell the story of
a structure to a builder and then see the structure built and utilized by
the end user.

Describe a typical workday from morning 'till night.
Currently I am a member of the structural residential team at a
boutique structural engineering firm. We mostly work with architects
and they dream up what the house (or community center, sculpture,
bridge, commercial building, etc.,) will look like and I design the bones
inside the building for structural integrity and public safety.

After arriving at work, I typically write a prioritized list of tasks I
wish to focus on for the day. They could be for one project or several.
I dedicate the start of my day to checking in with the architects I am
working with and responding to requests often via email or telephone.
I check in with any teammates I am working with. I set aside several
hours for detailed design calculations. These can be hand calculations
or using a spreadsheet or design software. I often work in 3D structural
modeling software for more complicated geometries. The architect may
have sent through some changes that need coordinating or checking to
ensure we have the right "bones" in place. We prepare and issue design
documents that outline what to build.

In the afternoon I may have a site visit to conduct where a project we have designed is now being built. I meet the contractor on site, and we walk through together to evaluate the construction to ensure it is in conformance with our design documents and building codes.

I review and verify that the correct member has been installed. A member is a structural element such as a column, beam or foundation wall. I also confirm it is built from the correct material such as steel, wood or concrete. Each of these materials have different grades, strengths or species and the correct one is important to ensure it can resist the forces it will experience. While on site I will point out any areas that need remediation.

We chat through potential fixes or areas where there is a conflict and how it can be resolved. I snap a lot of pictures. Once back in the office I prepare a report outlining the progress and any findings.

Other days may be full of meetings with clients or peers to discuss various design strategies for a project. I may attend seminars to further my knowledge. I recently have started consulting with engineering and architectural students at various universities to assist in developing their final projects.

Are you preparing for a different career?
I have thought about other careers, but I don't think I would stray too far from the engineering or project delivery field. It is dynamic and there are many possibilities. Essentially as an engineer I am good at solving problems and there are always more problems to be solved. I have had the privilege of working in dramatically different capacities in my young career and cannot see myself being bored.

Have you continued your studies?
Formally I have not continued my studies but in my own time I read textbooks and I also have several mentors who are teaching me various things at work every day. There are many different types of structures, materials and methodologies and my real world engineering education will never cease.

What are your current goals?
My current career goals are to be proficient at single family residential
design in wood and steel with concrete foundations. I have been
designing custom homes for about two years now and have much to
learn still. These are not your cookie cutter homes either – think giant
cantilevers, massive spaces, sweeping staircases, extensive windows
and unique layouts.

Do you have a ten year plan?
I have had detailed plans or a vision of what ten years would look like
but there have been events that completely derailed that plan. Now I
tend to design the larger picture and focus on what lights me up and
build a world around that. I value flexibility so I have financial goals
and work for a company that has less rigidity around working hours
and location.

I value adventure so I work for a company that does creative
and challenging work and I take time off to indulge in non-work
adventures. I feel most energized when I can teach and consulting
engineering allows me to work with junior engineers and university
students. My ten year plan is constantly changing, and every iteration
is different and exciting.

Where do you see yourself living in ten years?
In ten years, I see myself balanced between work and home life. I see
myself confident in my design abilities and working in consulting. I see
myself teaching part time at a college or university. I see myself as a
mom. I see myself returning to Ontario to live near friends and family.

Do you have a twenty year plan?
I don't have a twenty year plan as it feels too far and too exciting to
put boundaries on. I do see myself financially free, happily partnered,
with children embarking on their adventures. I see myself involved in
the design community to promote women in STEM fields. I see myself
reading a lot.

Do you have a retirement plan?
I subscribe to the idea of mini retirements while I am young, and my

responsibilities are less. I like the idea of productive sabbaticals and have been building in extended time off over my last ten years. So instead of a distant future retirement plan I have five year repeating retirement plans. I am also fortunate to be able to save for a legitimate future retirement. My end of life looks like a cozy spot with books, a garage for tinkering, good food, good friends, family and a life full of adventure stories.

How do you spend your leisure time?
I read or consume informational content a lot (podcasts, audiobooks, articles). Mostly nonfiction. I also ride and enjoy working on motorcycles. My partner and I both ride and we will go find great spots to camp on our bikes. I am curious about spirituality and consciousness. I play video games sometimes. I enjoy hanging out with friends in small groups where we can talk about big ideas. I love telling stories and making people laugh. This year I am going to seriously take up cooking.

What frightens you?
The potential brevity of life and squandering time. I find both fears motivating.

What saddens you?
Some big things such as climate change as a global issue and the divided elements in power that appear to have trouble collaborating on solving the crises. The skewed distribution of wealth. The extreme work culture and lack of balance in some professions.

What pleases you?
Simplicity. Cupcakes. Access to knowledge. Human touch and connection. Going to bed early. Good socks.

What advice would you give your younger self?
I know you don't want to but invest in yourself now: physically, emotionally, financially, technically. Find the most popular books on each of these topics and read them and put them to work. Focus particularly on emotionally as the relationship you have with yourself and others will dictate the quality of your life. Cultivate balanced discipline and question every built-in belief you have so you can

develop your own principles. Also, if you're gay–come out, if only to yourself, before university.

What advice would you give a young woman entering your field?
It's amazing. Designing and discovering is deeply satisfying. Yes, it is male-dominated, and most companies are currently run by men, but it is changing, and you are a part of that. Recognize there are imbalances between males and females but adjust and mold them from within by example. Within engineering (and life) there will be pain and there will be pleasure – it's all privilege.

MY WORDS; MY VOICE
Bev, thanks for this amazing opportunity. Women in STEM (science, technology, engineering and mathematics) fields are a vital component to the advancement of the built world. Having access to profiles of amazing women doing fantastic things could be a valuable tool for all women to inspire and impact. Thank you for doing this.

This is one of my favorite articles on the internet:
www.waitbutwhy.com/2015/12/the-tail-end.html

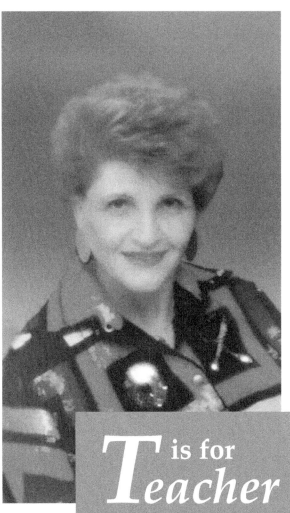

T is for *Teacher*

Judith Swift

After raising three children, Judith Swift (Judy) returned to school, earned her teaching degree and taught in the Miami Dade School District for over fifteen years in part time, full time and crisis counselor positions. She taught Language Arts (English) to a multicultural, multi-lingual student body, in low-income neighborhoods not familiar with English nor the American way of life. It was a joy for her when she accomplished her goal of teaching English speaking children English grammar, spelling, sentence structure and conversational skills.

I met Judy when I was a toddler and she was a teenager dating my uncle who just returned home from the Army. She was the first teenager in love I ever met and to this day after seventy-one years of marriage to my uncle, she exudes the same loving energy. She is devoted to family, embraced all of us and we responded in kind. She bought me my first pocketbook with a matching bonnet and along with another cousin, I served as her flower girl at her wedding. Through the years she has never missed sending a birthday, anniversary or holiday card for all her relatives – and there are many. I sincerely hope she owns stock in Hallmark.

She has boundless energy, lives life to the fullest and she and my uncle continue to travel extensively, attend all life event celebrations while thoroughly enjoying life with an extensive social calendar. She is and always has been a role model for me. I love her dearly and am proud that she has agreed to participate in this book.

Here are her answers to the questions:

Where were you born?
I was born in Brooklyn, New York.

How would you describe your childhood environment?
My environment was lower middle class during the Depression. Family always came first. After my grandfather died, the house was foreclosed, and we moved several times. The reason people moved was because if we found a one year lease, we got a free paint job and three month's

free rent. Another consideration was that my grandmother had heart problems and could not walk up the steps. We finally moved to a ground floor apartment. My parents stayed there for many years until they moved to Florida where I settled with my husband and children.

As a child, what did you hope to be when you grew up?
I wanted to be an actress.

Did you know as a child that you would be engaged in your chosen work?
No, but my second option would have been a teacher like my uncle because he had a car and his own "private" house.

Would you like to acknowledge one or more individuals who helped you shape your behavior, beliefs and work habits while on your early journey?
My parents, my grandmother, my aunt and uncle and my assistant principal with whom I worked.

As a young girl what difficulties did you have to overcome to move towards your dreams?
I married one year after high school and I didn't attend college until my youngest child was in kindergarten.

Where were you educated/trained for your work?
I attended Miami-Dade Junior College, Florida Atlantic University, Barry College and Nova University.

How much training did your work require?
I earned my undergraduate degree in Education, a graduate degree in Reading and a certification in Counseling and Gifted Education.

Once you entered the workplace, as a young woman, what obstacles did you have to overcome?
I only had a high school education and consequently I only was able to get clerical jobs.

As a woman, what challenges did you have to overcome?
When I graduated from Florida Atlantic University, my husband wanted me to spend more time with our own children, so I took a

less-demanding position as a substitute teacher in the school system for eight years. When I finally looked for a permanent job, the school system had a freeze and they were not hiring.

I worked for an employment agency and experienced racism when my boss looked at my head to see if I had "horns."

I tested for a civil service position and I worked for the state welfare division and then transferred to Aging and Adult Services where I became a supervisor. After about three years, I was advised that a teaching position was available at a middle school in an undesirable neighborhood some distance from home. I took it and after teaching for a few years, I became a "trust counselor" dealing with all the students. I loved it! The principal was moved to a school in Hialeah and he took me with him. Unfortunately, one of the assistant principals didn't understand or respect the program.

Are you satisfied with your chosen profession?
I am very unhappy today that much of the teaching is focused on teaching for the state test. As a counselor I believe that the profession is very important because of a lack of face to face communication, and an abundance of social media, drugs, etc.

Describe a typical work-day from morning 'till night.
No day was the same. I met with all the seventh graders with a specific curriculum geared to anti-drug and anti-tobacco use and the importance of finishing school. I taught peer counseling and was available for any problems that arose. I arranged field trips and various appearances by groups related to my curricula.

Are you preparing for a different career?
At this point of my life I am not looking for another career.

Have you continued your studies?
Not in school but I m a news junkie and I am an avid reader.

What are your current goals?
I have no goals related to work.

Do you have a ten year plan?
I hope to stay alive for the next ten years.

Where do you see yourself living in ten years?
Right where I am in Florida.

Do you have a twenty year plan?
I don't, but it's fun to think about.

Do you have a retirement plan?
My plan has materialized; I am happily retired.

How do you spend your leisure time?
I live in a "fifty-five plus" community or as I call it a "day camp." We have many activities, a gym, a pool, several classes, etc. I play Canasta and Mah Jongg and take part in other activities based on time, appeal and desire. I read and travel extensively with my husband. We spend as much time as possible with our children and grandchildren.

What frightens you?
I am afraid of illness and snakes.

What saddens you?
I am saddened by old age, the death of friends and the inability to be as physically active as I used to be.

What pleases you?
I am most pleased surrounded by family and friends, traveling with my husband, and reading.

What advice would you give your younger self?
Don't be afraid. Go for it! Give yourself credit.

What advice would you give a young woman entering your field?
I am not sure I would suggest teaching. Salaries are very low, there is no respect and little parental involvement. It seems like an uphill fight. If you do pursue education as a career, take advance degrees to qualify for more advanced positions.

MY WORDS; MY VOICE
I was born to a lower middle-class Jewish family in Brooklyn, New York. My mother's family immigrated from Romania, but my

mother was born in the United States of America. My father's family immigrated from Lodz, Poland when he was either three months old or two years old, the information wasn't clear. He was an insurance salesman which meant he had a route he covered to sell insurance and then collect the premiums weekly and monthly.

We lived in a two family house with my grandparents, aunts and uncles living upstairs. My parents and sister and I lived downstairs.

I adored my grandparents and worried my grandfather would poke his eye out because he drank tea from a glass and kept the spoon in it. He was a tailor and I loved to go the shop with him and see the big machine that went "woosh."

I remember being devastated when my friend Blossom, in a fit of temper shouted at me, "Your grandmother isn't even your grandmother." I was so horrified that I bit her. It seems my grandfather was married to my grandmother's sister and lived in America and together, they had a child. When her sister got sick, my grandmother had to come and take care of her sister and their little girl. After her sister passed, my grandmother and grandfather followed tradition, married and subsequently my mother was born. Blossom was wrong.

I was a flower girl at my aunt Ruth's wedding. She married a high school teacher, "A prestigious career" and they had a car and a house.

When I was four years old, I began having ear trouble and I had a mastoid operation. They shaved half my head of dark auburn curls and my mother had to shave the other half. My hair grew in brown and straight, so they gave me a permanent wave. I sat under a machine that made me feel I was being electrocuted.

I was a chubby child and my mother had to take me by bus to a chubbette store. It was very depressing and was another notch in demeaning my self-esteem. When discussing my childhood, I was told I was a brat and a tomboy.

When it was time to decide on a high school, I chose the one where my uncle taught instead of the local high school which most of my

elementary school classmates attended. I was a good student and was accepted to City College, Brooklyn College and Hunter College. But by then I had met my future husband and decided to work upon graduation. I had not taken any business courses, so all my jobs were clerical. I stopped working when I became pregnant with my first child.

A few years after we moved to Florida, I worked in a department store for the Christmas holidays and immediately knew that it was not what I wanted to do for the rest of my life. By then I was annoyed by the pettiness of women's groups and when a friend told me she was taking a course at the junior college, I joined her and was hooked on learning. Thanks to the cooperation of my husband and three children, five years later I had a college degree.

In high school, my guidance counselor had suggested that I study law. That seemed a lofty ambition and I reverted to my childhood dream of teaching. "You get summers and holidays off." Today, I am sorry I didn't have the confidence or courage to pursue a law degree.

My family have been very successful, and we live a wonderful life – traveling and enjoying family and friends. My children are great and have made me very proud and as a bonus I have five fabulous grandchildren, all of whom are doing well and provide me with much joy.

U is for
ndercover FBI Agent

Dana Ridenour

Dana spent most of her career as an undercover FBI agent, infiltrating various criminal organizations including domestic terrorism extremists.

After she graduated from Eastern Kentucky University with a Bachelor of Science in Police Administration in 1989, Dana attended Chase Law School where she earned her Juris Doctor in 1992. Dana entered on duty as a special agent with the FBI in 1995 and retired in 2016.

In 2003 Dana attended and passed the FBI's undercover school, thus allowing her to work as an undercover FBI agent.

During her career, Dana was assigned to four different FBI Field Divisions and had the opportunity to work a wide variety of cases to include multi-faceted narcotics investigations, domestic sex trafficking of minors, and violent crime. She was also a member of the FBI's Evidence Response Team where she and her team traveled to New York City in response to the 9/11 World Trade Center attack.

Dana has written several books inspired by her experiences as an undercover agent. Her first novel, *Behind The Mask*, won numerous literary awards and was named one of the Best Indie Books of 2016. Dana released her second award winning novel, *Beyond The Cabin*, on August 1, 2017, which received the 2018 Royal Palm Literary Award for Best Thriller or Suspense Novel. Dana's third book, *Below The Radar*, was released on August 13, 2019 and won the Hal Bernard Memorial Award for best novel presented by the Southeastern Writers Association.

Dana lives in the southeast where she is working on her fourth novel.

Upon meeting Dana, one is immediately struck by her intelligence, charm and quick wit. She has a fascinating story to tell.

Here are her answers to the questions:

Where were you born?
Louisville, Kentucky.

How would you describe your childhood environment?
I had an outstanding childhood. My father was a police officer and
my mother stayed at home with me and my younger sister. As a child,
my maternal grandparents lived next door; I was very close to them.
I grew up in a small town where everyone knew one another. I had
wonderful friends, some of which are still my close friends. I grew up
playing sports and taking music lessons. We were not rich, but we had
everything that we needed. My parents loved each other very much
and never argued. I always felt loved and cherished as a young child.

As a child, what did you hope to be when you grew up?
I wanted to be an astronaut, but then realized I wasn't good at math. I
also wanted to be a marine biologist, an archeologist and a Hollywood
movie director.

**Did you know as a child that you would be engaged in your
chosen work?**
I was always interested in my dad's work when I was a child. He was
a police officer, and I would sneak a look at the crime scene photos in
his work files. I have great respect for my father and I always wanted
to please him. My fate was sealed when I went to Washington, DC
on a band field trip my sophomore year of high school. We toured
FBI Headquarters and I knew immediately that I wanted to be an FBI
Special Agent. Friends even inscribed my high school yearbook, "Good
luck in the FBI." So, from the time I was fifteen years old, I knew I
wanted to be an FBI agent.

**Would you like to acknowledge one or more individuals who helped
you shape your behavior, beliefs and work habits while on your
early journey?**
My parents were instrumental in shaping my morals and beliefs. They
taught me right from wrong and showed me how to be empathic
toward others. I also had a band director in junior high and high
school, Mr. Paul Davis, who instilled a strong work ethic in all his
students. He insisted on hard work and accepted nothing less than us
giving 100 percent. I was athletic and played sports from the time I

could walk. Playing team sports teaches kids good sportsmanship and how to get along with others. My music teachers and my sports coaches were all huge influences in shaping me into the person I am now.

As a young girl what difficulties did you have to overcome to move towards your dreams?

I never bought into the premise that boys could do things better than girls. I always thought whatever a boy could do, I could do, and I would try to do it better. When I was in elementary school, I wanted to play little league baseball. However, back then they didn't allow girls to play baseball, so my dad signed me up for softball instead. It worked out for me, but I'm glad to know that today my granddaughter would be allowed to try out and play baseball if she chooses to do so. From the time I was fifteen years old I knew I wanted to be an FBI agent, so I found out what the physical requirements were for the job and I trained to make sure that I could pass the physical training test. I wasn't going to let the physical fitness requirements prevent me from achieving my dream of becoming a special agent.

Where were you educated/trained for your work?

I met with an FBI recruiter during my early college years and I found out what the standards were for getting into the FBI. The minimum requirements to get into the FBI required that a candidate be between the ages of twenty-three and thirty-seven, have a four-year college degree, be a U.S. citizen, have a driver's license and a clean background. In anticipation of applying to the FBI, I stayed out of legal trouble, avoided using recreational drugs, and received my four-year degree. In 1989 I graduated from Eastern Kentucky University with a Bachelor of Science in Police Administration with a minor in Psychology. In those days, the FBI was mostly hiring lawyers and accountants, so I went to law school. I received my Juris Doctor from Chase Law School in 1992.

How much training did your work require?

To become an FBI agent, each candidate must complete and pass all requirements during the twenty-one weeks at the FBI Academy in

Quantico, Virginia. In addition to my classroom sessions, I was trained in firearms, defensive tactics, physical fitness, evidence collection and defensive driving. I passed all of my tests in the academy and was sent to my first office, which was Alabama. I became a member of the FBI Evidence Response Team which required me to take advanced courses in evidence collection. Because I worked on a drug squad, I was also meth lab certified. I eventually decided to become an undercover agent which required that I pass the FBI undercover school to become a certified undercover agent.

Once you entered the workplace, as a young woman, what obstacles did you have to overcome?
I was a woman in a predominately male profession. I'm proud to say that during my twenty years as an FBI agent, I was treated fairly and never discriminated against because of my sex. That being said, I have always gotten along better with men than women in the workplace, so I think I have a personality that melds well when working with men. Most of the time I was the only woman on my squad. Working in law enforcement, I had to get used to being "hit on" by other law enforcement officers. It's pretty common for police to date other law enforcement officers, so I had to be able to stand up to aggressive men. I accepted this role when I entered into a profession where I knew I would be outnumbered by men. I earned the respect of my fellow squad members and the gentlemen on the squad always treated me fairly.

As a woman, what challenges did you have to overcome?
As a 5'2" female law enforcement officer, I had to work out and keep my body in shape. I was always encountering and arresting much larger subjects, so I had to be prepared for a fight. I trained in Tae Kwon Do because it not only kept my body in shape, but it also gave me confidence to know that I could handle almost any physical confrontation. In my early career, the FBI was still a "good old boys" club. So, as a woman, I had to learn how to navigate the waters without making enemies of the wrong people. It might sound silly but one of the biggest challenges that a female law enforcement officer has is

concealing a large weapon. As a small female, it was difficult to conceal the large Bureau issued firearm when wearing casual clothing. As an FBI agent, I was expected to carry my weapon at all times, including when off duty.

Are you satisfied with your chosen profession?
I'm extremely satisfied with my chosen profession. I had a wonderful career and retired after over twenty years of service. I worked in four different FBI field offices and met wonderful people along the way. I had so many amazing adventures as an FBI agent and I write about them now in my second career as a novelist. I was able to do nearly everything that I wanted to do as an FBI agent and the job lived up to my expectations. I'm not saying every day was peaches and cream, but for the most part it was a wonderful, exciting, and rewarding career. I was proud to protect the American people and uphold the Constitution of the United States.

Describe a typical work-day from morning 'till night.
This is a difficult question, because there is no typical work-day as an FBI agent. At any given hour the telephone could ring and send the squad out the door to work a major investigation. FBI agents work a minimum of fifty hours a week, and that includes irregular hours, and being on call 24/7, including holidays and weekends. A typical day also depended on what squad or office I was assigned to at the time. When I worked narcotics investigations, I worked a lot of long nights and weekends. It was difficult to plan activities around my work schedule because my schedule was subject to last minute changes. The last thirteen years of my career I worked mostly undercover investigations. When I worked in an undercover capacity, I worked 24/7. I gave up time with family and friends to work undercover matters. The job could be lonely at times, but I was good at working undercover and I enjoyed the challenge.

Are you preparing for a different career?
I retired from the FBI in 2016 and launched into my second career as a novelist. I published my first novel the day I retired from the FBI. Since

I retired from the FBI, I've written and published three novels and I'm currently working on a fourth novel.

Have you continued your studies?
As an author, I'm always learning. I regularly attend writing conferences and workshops to improve my craft.

What are your current goals?
My current goals are to finish my fourth novel. I've partnered with a screenwriter and we currently have a television series that we are trying to sell. I have an idea for another FBI series that I would like to write after I finish my fourth novel, which is not an FBI book. I'm going to do all of this while I learn to fish and enjoy my retirement.

Do you have a ten year plan?
I plan to continue writing my novels, spend quality time with my husband, travel, buy a boat and learn to fish.

Where do you see yourself living in ten years?
My husband and I bought our dream house in 2019 and we plan to stay in this house indefinitely. We live on the water in the South and couldn't ask for a more perfect place to call home.

Do you have a twenty year plan?
My twenty year plan would be to stay healthy, happy, travel and continue writing.

Do you have a retirement plan?
I've already retired from my first career, but at this point I don't have any plans to stop writing. Luckily, it's the kind of job that a person can do as they age. I plan to continue traveling and doing all the things that I enjoy now.

How do you spend your leisure time?
My husband and I both enjoy traveling, hiking, fishing and being outdoors. I also enjoy reading and playing guitar.

What frightens you?
Like most people, I'm scared of growing old and not having the quality of life that I enjoy now. I'm lucky to still have both of my parents, so I'm terrified of one day losing them.

What saddens you?

Seeing our country so divided saddens me. I'm not sure what we are going to do as a nation, but we have to do something soon. So many people are ugly and disrespectful toward others who do not agree with their political beliefs. It's sad to see what people say and do to one another. I also hate to see children, old people or animals harmed in any way.

What pleases you?

What pleases me most is spending time with the people I love. My husband, family and friends mean so much to me. I want to be able to enjoy these beautiful relationships while I have them. Life is short, so I don't want to squander time.

What advice would you give your younger self?

I would tell my younger self to take better care of her body. Living a long, healthy, pain free life is important, so I wish I would have put more of an emphasis on living a healthy lifestyle when I was much younger. I would also tell my younger self to live in the now. There are so many people that have passed on that I wish I had spent more time with while they were alive. I wish I would've asked my grandparents more questions and spent time getting to know them on a personal level better. They were marvelous grandparents, but I'm sure they were interesting people as well. I wish I would have spent more time with them while they were alive.

What advice would you give a young woman entering your field?

This is a wonderful time for women in law enforcement. I would tell any young person, to be respectful, work hard, and learn your job. Be accountable and not expect things to be given to you. Be strong and keep up your physical fitness. Women are smaller in stature, but the daily obstacles and duties faced on the job do not differ for men and women. Both are expected to be able to perform the necessary tasks to do their job and serve the community or the nation. Another bit of advice that I give to a new recruit, both male and female, is that law enforcement is not a career for people who think they are "entitled" to things. It is a career where you have to put in your time and earn the

respect of the senior agents and officers. It is a field of ups and downs with long hours. Enjoy the job, but don't forget about your family that may be waiting at home for you. At times it may be difficult, but always try to put your family first. Let your family know how much they mean to you and thank them for supporting your career dreams.

MY WORDS; MY VOICE

I spent most of my career as an FBI undercover agent, infiltrating criminal organizations including an organization of domestic terrorists. My first novel, *Behind The Mask*, is fiction but is based on my personal experiences working as an undercover agent. *Behind The Mask* won numerous literary awards and was named one of the best indie books of 2016 by Kirkus Reviews. The second novel in my FBI undercover series, *Beyond The Cabin*, was released on August 1, 2017 and was awarded the 2018 Royal Palm Literary Award for Best Thriller or Suspense. The third book in the series, *Below The Radar*, was released on August 13, 2019 and was awarded the Hal Bernard Memorial Award for best novel presented by the Southeastern Writers Association.

I enjoy meeting new people and I'm active on social media. I can be found on the following sites:

www.danaridenour.net

www.amazon.com/Dana-Ridenour/e/B01BKU5QFC?ref=sr_ntt_srch_
lnk_1&qid=1559226642&sr=8-1

www.facebook.com/danaridenourwriterpage

www.instagram.com/undercoverauthor

www.twitter.com/ridenour_dana

www.linkedin.com/in/dana-ridenour-00936bab

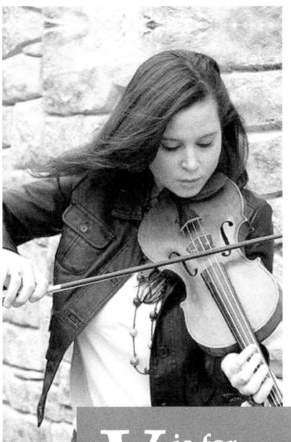

V is for
Violinist

Allison Ross

Violinist/violist Allison Ross is based in Kansas City, Missouri where she is a member of the (Missouri) St. Joseph Symphony Orchestra and concertmaster of the (Kansas) Westwood Ensemble. She has also performed with the Wichita, Topeka and Southeast Kansas symphonies.

A native of Ohio, Allison studied at the Oberlin Conservatory and won her first orchestral position with the Akron Symphony, concurrently freelancing for Cleveland-area Broadway shows such as *Fiddler on the Roof.*

In addition to performing, she currently enjoys managing a private studio for upper strings in the Kansas City area and teaching a music history undergraduate course through Fort Hays State University.

After Allison received an unusual medical diagnosis as a teen, she embarked on a mission to bring rare disease awareness to all fifty states through her nonprofit organization, Violin for Vasculitis.Learn more at **www.violinforvasculitis.org**. V4V has been featured on CNN's "Human Factor" and has reached its halfway point in June 2019.

Allison is as kind as she is talented, and I respect her decision to share her inspiring story as she moves from success to success while battling a formidable disease.

I know of Allison through her fund raising activities on behalf of vasculitis patients, of which I am one. Vasculitis, as defined by the Mayo Clinic, represents a group of rare diseases caused by inflammation of blood vessels. Changes in the blood vessel walls often result in narrowing, weakening, thickening or scarring and may restrict blood flow to one or more organs throughout the body, which may cause organ or tissue damage.

Allison's tireless fundraising efforts through her company Violin for Vasculitis not only provides support for patients but brings awareness to the public and contributes money for research into rare diseases through love and music.

Here are her answers to the questions:

Where were you born?
Akron, Ohio.

How would you describe your childhood environment?
The fact that I was home schooled dominated much of my childhood. Mom stayed home to make sure we kids got a quality and specialized education. She taught me herself in the early years, then we switched to a video program. I had an insatiable appetite for reading, and much of what I learned about the world as a grade schooler was absorbed from classic literature. Once my work was finished, I was allowed to explore the many acres of open woods next to our house (usually with a book or two in hand). As my siblings and I got older, we developed a flexible schedule that allowed for us to finish the work we had to do, then budget in time to practice music, play soccer, and be involved in church activities.

My brother and sister attended their last couple of years at a public high school, but I never did. As I'd grown up being fairly self-reliant on my own schedule and interests, I find as an adult that this sort of personal freedom is a significant part of my career motivation.

As a child, what did you hope to be when you grew up?
At first, I wanted something to do with animals, but as a preteen, my goals developed more towards "violinist."

Did you know as a child that you would be engaged in your chosen work?
I knew by the age of thirteen that music was where I would end up.

Would you like to acknowledge one or more individuals who helped you shape your behavior, beliefs and work habits while on your early journey?
My violin teacher in high school, David Russell, went beyond the label of instructor to also become a mentor. Though I was expected to work hard on difficult repertoire, he never demanded perfection and infused every music lesson with keen observations on life. The music became not just technical practice, but a fascinating study on character and culture. His combination of musical guidance and humanity remains

with me today, especially as I guide my own string students to become not just good musicians but also well-rounded people.

As a young girl what difficulties did you have to overcome to move towards your dreams?
During my early childhood, I was blissfully naïve about the hardships that can befall someone. But at the age of sixteen, I became suddenly very ill with acute respiratory issues. In a shockingly short amount of time, I was in the hospital having tests run and blood transfusions performed in order to save my life. It would be five months of multiple specialist visits, rigorous treatments, and significant physical limitations before a diagnosis was reached: Granulomatosis with Polyangiitis (then called Wegener's Granulomatosis). It is an inflammatory autoimmune disorder that is still not completely understood by modern physicians. What we do know is that I'll have it for the rest of my life, and though thankfully I'm in remission these days, I take maintenance meds daily and am always on guard ready to notice any unusual changes in my body.

Where were you educated/trained for your work?
Growing up in Northeast Ohio meant an abundance of options for budding musicians. I studied under Cleveland Institute of Music faculty and was accepted into the Cleveland Orchestra Youth Orchestra. With an interest in the viola as well as violin, I also commuted to the Oberlin Conservatory to study with Peter Slowik, an international pedagogue and another excellent example of humanity within the arts world. When college auditions arose, I had my eye on California and even auditioned and was accepted at UCLA's music program – but eventually opted to stay in Ohio for financial and medical reasons. I earned a degree in music at the Oberlin Conservatory and went on to obtain a graduate degree that also encompassed music history at the University of Akron.

How much training did your work require?
Music is something I've studied since the age of seven. It's safe to say I completed my "ten thousand hours" of fluency early on, but

its complexity is a lifelong challenge to understand and convey. The real training in a freelance/self-employed career has more to do with organization, people skills, and continually diversifying oneself. In the past decade, I've taught hundreds of students, performed with several professional symphony orchestras, and even had a few years' stint as a Cleveland-area Broadway musical pit musician (including playing the character of *Fiddler on the Roof* four times!).

Once you entered the workplace, as a young woman, what obstacles did you have to overcome?
My health has been an issue ever since that initial setback in 2004 – nearly half my life now. It's caused me to miss many hours of practice, limited my financial freedom, and forced me to consider my values in a very real way. If tomorrow I became somehow disabled, I know I could go on without the ability to play music, because I've developed other areas of my life that fulfill my worth as a human being.

As a woman, what challenges did you have to overcome?
I'm fortunate to work in the arts industry, where sexism is minimal and there is widespread acceptance of all backgrounds. Not once have I felt as though my gender was a roadblock on the path to my goals.

Are you satisfied with your chosen profession?
I love that what I do is rarely the same from day to day! I don't think I could work a traditional job without feeling incredibly stagnant. In my late twenties I realized that I might need to remain self-employed forever in order to keep my mind engaged and my career drive active. But who knows how I may feel in another decade or two.

Describe a typical work-day from morning 'till night.
My schedule is one of the reasons I enjoy what I do so much. Due to my chronic health situation, I always go to bed before 11 p.m. and am rarely awake before 8 a.m., giving my body plenty of time to rest. Breakfast is a big, healthy meal, and a mug or two of loose-leaf tea. Most weekdays I go to the local high school to accompany the choir program (this is where my piano training has found its way into my career). When I get home in the afternoon, I have an hour or so of

"quiet time" before students show up for private lessons. Somewhere throughout the day I manage to get in a workout and grade papers for the online class I teach. During the academic year, there is usually also a 7 p.m. orchestra rehearsal on the calendar at least a few evenings per week. Weekends are hit-or-miss whether I'll be out of town playing a gig somewhere, but Sundays are almost always reserved for time with my husband and dog, and to regroup before the week comes back around. Like I said, it can be inconsistent, but that's half the appeal to me.

Are you preparing for a different career?
Not at this time. I told myself that in my thirties I'll stay where I am because I've been successful (by my definition,) but as I approach forty, I'll reassess and consider how I want the next decade of my life to take shape.

Have you continued your studies?
You may have noticed, in the daily schedule above, that I didn't mention practice! That's because it varies from day to day. Adult musicians are lucky to get an hour or two a day of quality time at their instrument, but we learn to practice efficiently so really that's all that's needed. Some days "practice" consists of listening to and studying orchestra repertoire; other days, I don't pick up my violin at all. The muscle memory I've developed over twenty-three years of playing allows me to utilize minimal time to get results. When there is a concert on the horizon and I do need to prepare, I find that the first thing in the morning or during the calm hours of the evening is best, when there aren't as many distractions.

What are your current goals?
My primary goal at this point in my life is to maintain a comfortable, loving home for myself and my husband, Brian. He works as a pharmacy technician at a major hospital system in downtown Kansas City. Our hours usually overlap in strange ways, so we make it a priority to have dinner together a few times per week and also set aside time on the weekends to do something outdoors with our Alaskan

Malamute, who needs lots of exercise! Beyond taking care of our "pack," I want to work hard enough to completely pay off debt.

Musicians are already notorious for living modestly, but my wallet carries the additional burden of health-related costs. I can honestly say that regarding music, I've achieved my goal of living comfortably within a sustainable lifestyle. I've allowed myself the flexibility to work in several different areas (university adjunct, private teacher, high school accompanist, freelancer) and continued to stay active on three instruments, which certainly expands my horizons.

Do you have a ten year plan?
Grow my studio and visit all fifty states through my non-profit awareness initiative, Violin for Vasculitis, Inc.
www.violinforvasculitis.org.

Where do you see yourself living in ten years?
The bustling Kansas City metro area has been very good for both myself and my husband since we relocated here for work opportunities and as far as we can see, there is no reason to leave!

Do you have a twenty year plan?
My association with the Vasculitis Foundation reached a new milestone when I was elected to the Board of Directors. Several hours of my week are spent fundraising, communicating with patients, and doing various other tasks to further the cause. I'd like to think that twenty years from now, I would still have a significant part to play in this organization, as well as to have completed my fifty state mission with Violin for Vasculitis. At that point, I'll take it international, and write a book.

Aside from civic-oriented plans...while I don't intend to have children, my love of animals has never dwindled. My current household menagerie of fish, leopard geckos, and our giant Northern dog will probably expand to include another dog or two, and maybe also a parrot. This goal may seem trivial to some, but it is thrilling to experience the unconditional companionship and amusement animals can provide.

Do you have a retirement plan?
No retirement plan and god willing, no need for one. Most musicians keep playing and teaching late in life, even if it means decreasing the number of students or performances as we grow older.

How do you spend your leisure time?
I read between forty to fifty books per year which amounts to about an hour a day. History, philosophy, biography, and economics are my favorite topics. The combination of them leads to a general fascination with market forces and libertarian policy, so there is a couple of podcasts I listen to on that subject. I also play soccer on Sundays through a local women's league. Sometimes, it seems like there is so much out there to learn that I really can't afford to let my mind relax. That's what eight to ten hours of sleep per night is for.

What frightens you?
After nearly losing my life to a rare illness, there's not much that can scare me – but I am very afraid of swimming in lakes or the ocean.

What saddens you?
This is such an interesting question. I suppose I would say that, when people encounter hardship and they fully blame external circumstances, that disappoints me. There are many types of disadvantages a person can face, but everyone has the potential within themselves to overcome, adopt, and thrive.

What pleases you?
Flowers. Birds. A good song. A delicious cup of loose-leaf tea. Really, because of my over-active brain, I am very easy to keep happy.

What advice would you give your younger self?
Don't be so impetuous. You have plenty of time to fit in all of those experiences you crave – no need to dive in head-first, without considering the long-range consequences.

What advice would you give a young woman entering your field?
If you plan to freelance, the hustle will start early and never end. Say yes to every decent opportunity that presents itself. It takes a certain

personality type that is willing to accept the unreliability of this lifestyle and keep pushing forward. But if you take on the challenge of working for yourself, it is also one of the most personally rewarding things you will ever do.

MY WORDS; MY VOICE

Turning thirty was a real mental crisis for me. Older adults chuckle when I say that. I am still so young. But some days it doesn't feel that way. My personal growth in the past decade was monumental in every aspect of my life. It didn't help that I got restless and moved across the country at twenty-eight, and therefore had a huge change in environment and relationships as I started over just prior to my thirtieth birthday. The thought that I am running out of time "time for what?" is an irrational fear that has me working harder and searching desperately for something, (something that is what?) with every year that passes.

I am always so encouraged to hear from older women who have achieved their goals, including, Bev. It is a paradigm shift to realize that age truly doesn't mean anything at all. Someday I probably will turn eighty, take a look back at the past half-century and laugh at myself that I am writing this now. Or, maybe that year will bring another crisis. Who knows?

Please check out Violin for Vasculitis and help support our mission in any way you can! As of this writing there are still twenty-three states to visit. Each event includes a musical performance, then I share my story of illness and recovery, followed by questions and answers.

www.violinforvasculitis.org

Photo by Mikul Robins.

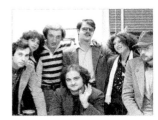

Photo by Edie Baskin.

*Tom Schiller, Rosie Shuster,
Alan Zweibel, John Belushi,
Dan Aykroyd, Anne Beatts,
and Michael O'Donoghue.*
© COPYRIGHT EDIE BASKIN 1975.

W is for
riter

Anne Beatts

Anne Beatts is a TV writer-producer who won two Emmys as a writer for the original *Saturday Night Live* show. She created and produced *Square Pegs*, on CBS, and co-executive-produced NBC's *A Different World*. With Dan Aykroyd and Judy Belushi, she is currently developing a TV series featuring the Blues Brothers.

She and her producing partner, Eve Brandstein, recently executive-produced and co-directed *John Waters Presents: Movies That Will Corrupt You*, a premium cable film series.

In 1999, she returned to *Saturday Night Live* as a writer on NBC's Emmy-winning twenty-fifth anniversary special, for which she won her fourth WGA Award. In 1995-96 she was executive producer of *The Stephanie Miller Show*, a late-night talk show.

She was the first woman Contributing Editor of the *National Lampoon* and both performed and wrote for the *National Lampoon Radio Hour*. She has been published in *Esquire*, *Playboy*, *Los Angeles Magazine*, *Vogue*, *Elle*, and *Salon.com*. In 1997-98, her humor column "Beatts Me!" appeared weekly in the *Los Angeles Times.*

She co-edited the best-selling *Saturday Night Live* (Avon, 1977), *Titters: The First Collection of Humor by Women* (Macmillan, 1976), and *Titters 101* (Putnam's, 1984), and co-authored *The Mom Book* (Dell, 1986).

Her work has appeared on Broadway in *Gilda: Live* and the Tony-nominated rock'n'roll musical *Leader of the Pack.*

In addition to teaching at UCLA in both the graduate and summer writing programs, she has taught film and television writing at USC's School of Cinematic Arts, the School of Cinema and Television Arts at California State University at Northridge, at the Academy of Art University in San Francisco, and at Dodge College of Film and Media Arts at Chapman University. She also spent a week at the University of North Carolina, Chapel Hill, as the Evan Frankel Visiting Professor. She was recently honored by the Museum of Television and Radio as one of

the medium's most influential women in their "She Made It" awards, and her interview has been archived by ATAS (Academy of Television Arts and Sciences.)

I knew of Anne Beatts by her work and reputation and respect the fact that she succeeded in a world dominated by men. I am delighted she agreed to share her story.

Here are her answers to the questions:

Where were you born?
Buffalo, New York, during a blizzard. We left after six months, so I don't have any memories of Buffalo as a child; no memories of snow until I was six.

How would you describe your childhood environment?
Unorthodox. My parents were iconoclastic and very different from other parents. My father was British, born in India. He was a naturalized American citizen, but very British. My mother was English Canadian. I have an older sister and she and I called them by their first names. I was amazed to discover that one of my playmates who lived next door didn't know her mother's first name.

My childhood was a little like being an Army brat, because we moved around a lot. My father was a teacher, and initially, when I was quite small, he worked for a very wealthy family. The mother of the family believed in my father's educational theories and wanted him to tutor her son. Because of that, we followed them from Greenwich, Connecticut, in the summer, to St. Petersburg, Florida, in the winter and lived in rented houses provided by the family. During those years, I never spent two Christmases or two birthdays in the same house until I was seven.

But my father's patron died unexpectedly of a heart attack. She had promised my father that she would help him found his own school, but when she died, that dream went away, and our lifestyle changed.

My father got a job teaching at the Palm Beach Private School in Palm Beach, Florida. And that was where I first went to school. I already

knew how to read and everyone else was going *See Spot Run.* I was terrifically bored, so my teacher suggested that instead of staying with my fellow first graders, I help out the kindergarten teacher, whom I adored. This was probably a formative step in encouraging me to want to be in charge.

My father left that job, and started working in the education department of IBM, so we moved to Highland, New York. I was homeschooled because my parents didn't approve of the local public school. And my sister had been pretty much educated at home for a long time. We had courses from the Calvert School, which was a mail order school used by military families and people who traveled a lot.

My mother was teaching my sister and I went along with my sister's lessons. She is seven years older than me, so obviously her lessons were quite advanced. But when we moved to Millbrook, New York, my sister persuaded my parents to put me in public school, so I started in third grade, which was quite a shock, I can tell you.

My parents were dissatisfied with that school, so they got together with some other families and started their own school, called the Dutchess Day School, still going strong sixty-four years later. I stayed through the seventh grade. Because of another job transfer, we moved to Somers, New York, and I entered the public school system, skipped a grade and at the age of twelve entered ninth grade.

We were very much free spirits. I'm grateful to my parents for giving me an unorthodox upbringing in which I learned that anything is possible, and you can be who you want to be. But at the same time, they, left us woefully unequipped to deal with the world as it is. We were very isolated. But what did I find in in that isolation? I found reading and books and movies and the world of the imagination. I liked to read and am still a voracious reader.

As a child, what did you hope to be when you grew up?
I really didn't know. But I was interested in archeology and I remember that I had to write a pamphlet in high school about my future career. What I chose was archaeological writer.

I wanted to know how other people lived. On Halloween people would actually invite you into their homes when you went trick-or-treating. Sometimes you would be asked if you had a party piece, because, back in the day, children always had something that they memorized and could recite on cue. And of course, I did have something I could recite. I could see inside other people's homes and sometimes I got to perform.

It was great because, not only did you get to dress up, but you got candy, before UNICEF took over and ruined it when they made you ask for money. Now UNICEF seems to be out of the picture and it's back to candy again, but no more performing.

Did you know as a child that you would be engaged in your chosen work?
No. In my junior year of high school, my parents split up. My father had been making me take extra courses every year. I had enough credits to skip a grade and graduate at the age of fifteen. My mother took us back to Montreal and got me into McGill University, where I was an English major. McGill did not offer any courses in archeology, or comedy, for that matter.

Would you like to acknowledge one or more individuals who helped you shape your behavior, beliefs and work habits while on your early journey?
Certainly, teachers that I had in high school, my Latin teacher Samuel Bodanza, people like that had an effect on me. But I wouldn't say that they were role models or mentors.

There were writers whom I admired like James Thurber and Terry Southern. Paul Krassner, the editor and publisher of a satirical underground publication called *The Realist*, made a particular impression on me when he said in an interview that the role of the satirist was pointing out that the emperor is not wearing any clothes.

Nick Salomon, the creative director of Vernon's, the ad agency where I first worked in television in England, said something that always stuck in my mind: "In life, we should have more pleasant treats." I do believe

that life should have more pleasant treats and I have always tried to live up to that.

My boyfriend Michael O'Donoghue was a major mentor to me and to everyone at the *National Lampoon*. He really could put his finger on what was good about ideas that you had and how to execute them. He would say, "That's funny. You should write that down." And if he said something was funny, you believed him – and usually it was.

My boyfriend during most of my years at *Saturday Night Live*, the producer/director James Signorelli, who took over producing the parody commercials from me, taught me a lot about how to execute comedy on film. He also had an interesting saying: "Some people take drugs; other people take revenge." Which is a little different as a philosophy of life than "more pleasant treats, please," but also works for me. He was Sicilian.

My parents and my sister were very important to me, my father particularly. His love of words, language and literature was a major influence on me, in particular his sense of humor because he loved comedy and had a whole repertoire of jokes. As a child, I valued laughter and wanted to make people laugh, especially my parents.

I remember two incidents at the movies when I was a little child. When president Truman came on in a newsreel I unwittingly remarked, "Oh, there's that SOB Truman." Because that's the only way I'd ever heard my father refer to him and I just thought it was his name. It was a mainly Republican audience in Greenwich, Connecticut, so of course everyone laughed.

The second time was during a movie called *Wagons West*. My father loved Westerns. I remember that a woman was about to give birth on the wagon train and I piped up with, "Quick, fetch the boiling water!" and everyone in the theater laughed. And I thought, hey, everyone laughed. The power of laughter made me feel good.

As a young girl what difficulties did you have to overcome to move towards your dreams?
At the age of twelve, when I couldn't see the blackboard, my eyes

were tested, and I began wearing glasses, pre-Tina Fey and, pre-Harry
Potter. Wearing glasses was a blow to my self-esteem. I was "four
eyes" and all that. And as Dorothy Parker famously said, "Men seldom
make passes at girls who wear glasses." I had to overcome being the
ugly duckling and the cuckoo in the nest because of the way that I'd
been raised and educated. Being younger than the other girls, I was
wearing undershirts and they were wearing bras, even if they were
padded bras. I had no sense of how to behave and I spoke way too
correctly. I remember making a conscious effort later to dumb down
my vocabulary, because I was such an egghead, so I was the ultimate
square peg.

My mother always said, "Someday you'll look back at all this and
laugh." I didn't realize that it would take me twenty years to turn
my high school trauma into the first television series I created and
produced: *Square Pegs.* The unofficial show motto was: "Remember
how lame you were in high school, and you survived."

I not only survived, but I was elected Student Council Secretary,
performed in various school productions, eventually became the editor
of the student newspaper, and was salutatorian of my graduating
class, despite skipping a grade. I would have been valedictorian if
not for my nemesis, Physics. While I excelled in school academically
and to a degree socially, I never really won social acceptance by the
popular kids.

Many years later I went back to my high school reunion. At that point
in my career I had just become the Executive Producer of *A Different
World,* I was making a fair amount of money, living bi-coastally in
New York and LA, and had done *Saturday Night Live.* My name was
out there, so I felt like I had a right to be at the popular kids' table. I
was getting dressed to go to the first event of the reunion and I tore
my contact lens. I ended up having to wear my glasses–God's sense of
humor, I guess. And I still didn't get to sit with the popular kids.

Where were you educated/trained for your work?
I was an English major at McGill University, which really doesn't
qualify you for anything. Every time I meet an English major, I say,

"Oh, my sympathies." In my opinion, being an English major doesn't qualify you for anything except going on to get a higher degree and then teaching other people to be English majors.

Having been the editor of my high school newspaper, I naturally gravitated towards the *McGill Daily*. McGill had a daily student-run newspaper. Most of the people who worked on the *McGill Daily* were Jewish and left-handed, neither of which I was. But I was an outsider and I recognized my fellow outsiders, and I threw myself into that world enthusiastically. I practically lived in the Student Union. I was in the Players Club, co-editor of the McGill handbook and, ultimately, I became editor of the entertainment section of the *McGill Daily*, which was called "Panorama." People used to joke that it was called "Panorama" because we panned everything.

While I was in college, my mom briefly dated the Vice President of the Aluminum Company of Canada and through him, I got my first real job, writing brochures about aluminum extrusions. After that, I got a job as a copywriter for a fancy department store in Montreal and I wrote newspaper fashion ads.

My then boyfriend, Herby Aronoff, dropped out of McGill and moved to Toronto. I followed him and applied for a job as a copywriter at an ad agency, intending to finish my studies at the University of Toronto at night. They asked me to submit a sample of a television ad. I had already told them I didn't have a television – I was a starving student. I then turned in a sample television commercial that was almost word for word the exact same commercial for Jello pudding they had on the air, about scraping the pot. So, I had to be either extremely smart or extremely stupid, and I guess they thought the former, because they hired me, and I wrote television commercials for the first time.

My boyfriend decided I should go back to Montreal, so I ended up graduating from McGill with honors in English in 1966. Then we got engaged and I went back to Toronto and continued to work as a copywriter. But Herby was hired as the entertainment director of *Expo '67*, so it was back to Montreal again. I managed to get another copywriting job at an ad agency, where I wrote a book called *The World*

of Salt, which told you more about salt than you ever wanted
to know.

When *Expo '67* ended, we hitchhiked around Europe and settled in
London. But Herby decided to go back to Montreal, and I was in
London for about a year on my own. I was working for Nick Salaman
at Vernon's, writing sixty second television commercials shot on film
in black and white, because they didn't have color TV in England yet.
They were like mini-movies, filmed on locations much like *Downton
Abbey*, with wonderful British character actors. It was the era of
Swinging London. My miniskirts were so short they were more like
blouses. You could basically see my underwear all the time. I was on
the pill. My life was full of pleasant treats.

Then I returned to Montreal to get married, didn't get married, and
went to Woodstock instead. And I got another job as a copywriter.

How much training did your work require?
There were no classes for comedy writing, like the ones I teach now. So,
it was all on-the-job training.

The beginning of my career in comedy writing was because of my
relationship with Michel Choquette, whom I met in Montreal on a blind
date. He was working with these two Harvard guys, Doug Kenney
and Henry Beard, who were starting the *National Lampoon* magazine.
Michel brought me to New York. Initially, I was "helping Michel with
his work." The Lampoon had these editorial dinners, where a small
group of people who put out the magazine every month would discuss
their ideas for upcoming issues, usually in the cheesiest restaurants,
like *Steak'n'Brew*. And Michel would bring me to dinner – after all, it
was a free meal. But I wouldn't just sit there. I would come up with
ideas and then later people would say, "Well, whose idea was that?"
And it would turn out to be my idea. And then if they wanted to use it,
they would have to let me do it. Eventually I became the first woman
Contributing Editor. So, I made it to the masthead, even though it was
an unpaid position. But I always had to fight to get my work in the
magazine, and even to get paid for it. Because the guys said more than

once, "Chicks just aren't funny."

Michel left for Europe and I switched boyfriends in mid-magazine and wound up with Michael O'Donoghue. Michael was really a taste arbiter at the Lampoon, and later at *Saturday Night Live*. Before the Lampoon, he had been a fixture in the New York underground arts scene for a few years. He was a published author – *Evergreen* magazine had run his comic strip, *Phoebe Zeitgeist*, and published a bound collection of the strips. But it was really more his attitude that gave him his position as an unquestioned authority on all comedic matters.

Michael and I were together for four years. He encouraged me and gave me more confidence in my writing because I really did not have confidence in it. I had not felt the same about advertising because I didn't care about it. This was something that I put my name on, that I was invested in, that I wanted people to like, that I wanted to be good. So, he gave me confidence and he gave me presents. He was very good at giving presents that spoke to your secret self, the person you would like to be but weren't sure anyone else would recognize. He gave me a vintage white ermine cocktail jacket with "Fifi" embroidered on the inside pocket. I still have it, though it doesn't get much wear these days.

Michael and I both left the Lampoon in a big blow-up with the publisher, Matty Simmons. We struggled for about a year to make ends meet and to pay what was then considered the horrendous rent of $750 a month on our downtown floor-through brownstone apartment. I freelanced for various T-and-A publications like *Oui* magazine, published by *Playboy*, and Michael mostly moped around the apartment suffering migraines.

Then Lorne Michaels came to town. Lorne heard about Michael from a writer he was hiring, Marilyn Suzanne Miller, who was a fan of Michael's work. He offered Michael a job on this new late-night TV show he was starting up, *Saturday Night.* The "Live" was added later. And he offered me a job too. When I asked why it was called *Saturday Night* – what a stupid name! – Lorne brilliantly commented, "So the

network can remember when it's on." I think Lorne liked the idea of hiring couples, maybe because he knew the show would be like the Ark – once you got on, you couldn't get off, and you certainly wouldn't have the time or ability to date outside the show.

Meanwhile, my friend Deanne Stillman and I had sold a book to Macmillan, *Titters: The First Collection of Humor by Women.* So, when Lorne offered me the job I said no, because of the book. I had no desire to write for television, which to me was basically a lava lamp with sound. If it had been something to do with movies, it would have been different.

My friend, Penny Stallings, who had helped us sell the book, said, "You can't turn this down. This is an offer you can't refuse." And Lorne sort of twisted my arm and said, "Oh, you can do the book too, no problem." So, I took the job.

Once you entered the workplace, as a young woman, what obstacles did you have to overcome?

I would say being a young woman was an obstacle to overcome because it was hard to be taken seriously. And I think also I created obstacles for myself in that I wasn't really sure that I had the right to a career. In other words, as opposed to getting married and having children and maybe having to work just on the side or something like that–actually having the ambition to have a career, especially as a woman who writes comedy.

I would have liked to have been on camera more, on *Saturday Night Live.* I always took the extra jobs because AFTRA (American Federation of Television and Radio Artists) mandated something like $350 for extras and the writers were given first shot at it. The first thing I did was the first thing ever shot in studio H, which was my speed commercial, which I insisted on performing myself. Some people still think it's Laraine Newman. But the problem was that the women who were hired to perform were struggling to get time on camera. It was just really hard to throw your hat in the ring and compete with them when basically the female writers were tasked with the job of

representing "the girls," as they were always called, by writing for them. How could
we compete?

So, while things have improved tremendously, they haven't changed enough, in my opinion.

Humor is a weapon and men are reluctant to put that weapon in the hands of women. There is just this opposition to women in comedy that still persists. And I would say that it's born from fear, because, to put it bluntly, men are afraid that the ultimate joke will be dick size.

As a woman, what challenges did you have to overcome?
Sexism: My relationship with Michael really went down the tubes because he could accept me much more easily when he was mentoring me than when we were both writing in the same category. Lorne Michaels hired us as a couple for *Saturday Night Live* and we were both on more of an even keel. Interestingly, after they hired us, at a certain point, NBC called me and said, "we've been overpaying you and you have to give us some money back." They weren't supposed to be paying me as much as Michael. I went to Lorne and said, "I can't pay the money back and I need to get the same amount." And he said, okay. It was very generous of him and in those times, rare.

Ageism: I'm seventy-two. Unfortunately, I think for a man, it's not as much of an issue in Hollywood. And, there's still stuff I would like to do.

Are you satisfied with your chosen profession?
No, I'm not satisfied with it. I'm proud of it, but in Hollywood I've had many, many projects that I've tried to make happen that have not happened, that I've been disappointed by.

Describe a typical work-day from morning 'till night
On *Saturday Night Live,* you were available twenty-four hours. The first year of the show I was also producing the parody commercials because Lorne knew that I'd worked in advertising and I knew what commercials were.

There wasn't a typical workday. The way that the show worked, and I believe still works, is that you would come in on a Monday night and pitch your ideas for that week, sometimes knowing who the host was, and sometimes you wouldn't know until that point. Lorne would put cards up on the board and then you would probably go off and eat and then you would come in Tuesday, in the afternoon or early evening and end up spending Tuesday night writing. The read-through would be on Wednesday in the afternoon, usually about three o'clock. Then the host and Lorne would discuss what they were going to put in the show, behind closed doors.

Then you would find out whether your piece was in the show or not in the show. Of course you would get an idea at the read-through if it bombed, or if it was successful, and people laughed. Then you would either have to stay up another night rewriting it or maybe go home, get some sleep, get up really early the next morning and work on rewriting it. Or, if you were lucky, it would be scheduled to be rehearsed in the studio on Friday and then you would not have to rewrite it until the next day. Things that required more complicated sets were usually a good bet for Fridays.

Then there would be camera blocking, in other words rehearsing on camera, starting at one o'clock in the afternoon and ending at eight o'clock on Thursdays. But on Fridays we would sometimes go as late as one o'clock in the morning and there would be more notes and more rewrites and sometimes your piece would get cut at that point, or really at any point.

Then you would come in for a dress rehearsal on Saturday at one o'clock p.m. and you would be in the studio from one o'clock p.m. until one o'clock a.m. Your piece could be cut from the show at any point. And if it wasn't cut, you probably would have to edit it. Lorne would say, "Can you take out two minutes?" If you wanted it in the show, the answer was always "Sure." So you'd have to cut lines and rewrite it and then get all those changes to the actors, the control room, and cue cards between dress and air.

At the end of the show, you would go out and party, go to the official party and then the after party and then maybe get home around six or seven o'clock in the morning, sleep and try and wake up in time to watch *60 Minutes*. Then you'd start again. Every three weeks you'd get a week off where you'd try and cram everything that you'd missed doing during three weeks into one week; like laundry.

So it was very pressured. The great thing about it was, it was like school. It started in the fall and ended in the spring and you got big chunks of time off at Christmas and Easter and things like that. I did that for five years.

Are you preparing for a different career?
In a way I am preparing for a different career, but I don't know what it is. I'm a single parent with a daughter in the last year of high school, so when and if she goes off to college my life will change radically. I have a friend who was in roughly the same situation as me, a single parent who raised a son. Now she's reinvented herself as a theater director, which is not necessarily something I would do, but it's just interesting to me that it happened.

Have you continued your studies?
Yes. In the school of hard knocks.

What are your current goals?
I would like to do more work and whether that will be in film, television, or publishing, some form of communication with the public. I'm not quite sure. But I know that I'm not going to give up working and that I hope to return to putting more focus on that. I'm hoping to revive my career in some way, but in what turn that will take, I'm not sure.

Do you have a ten-year plan?
I'm writing, I'm working on a book and I have other ideas and projects that I might have more time to put my energy into.

Where do you see yourself living in ten years?
I fantasize about living in Paris in ten years, but I don't know if that

that's going to happen.

Do you have a twenty-year plan?
My twenty-year plan is still to be alive.

Do you have a retirement plan?
I can't afford to retire. Other than my fantasy of living in Paris, maybe the South of France. But I do have a plan of creative expansion of some kind.

How do you spend your leisure time?
I don't have any leisure time! Grading. I spend my leisure time grading papers. No, that's not entirely true. My daughter and I take vacations. Thank goodness she still wants to vacation with her mom. She and I went to New York for a week at Thanksgiving and saw friends and went shopping and to the theatre and museums and had a great time.

Two summers ago, we drove Route One up the coast from here to San Francisco. My daughter did all the driving. We went to Palm Springs this past summer. It was super hot but we had a house with a pool, and we had a lot of fun teaching the big dog to swim. We're going back there after Christmas. We have two dogs, two cats and she has fish. I turn the light on and off for the fish, but I stay away from the rest of it. But the dogs and cats I get caught up in caring for.

What frightens you?
Trump frightens me. I don't know when this book is coming out, so we have no idea what's going to happen politically in the future. But right now, that's what frightens me a whole lot.

Aging frightens me a bit. The idea that this is going to end at some point, and how far am I going to make it? And not having the energy that I used to have. Because I used to have boundless energy, which is obvious from the schedule that I described to you at *Saturday Night Live*, and that's not something I could do now. I can't even stay awake to watch *Saturday Night Live*, so I have to watch it the day after.

The state of our environment frightens me.

What saddens you?
The same thing that frightens me, saddens me, which is the state of the

environment. And general ignorance.

What pleases you?
Well, you know, it's a wonderful world, isn't it? I mean, it is a wonderful, beautiful world and we should be grateful for it. Here I am in California. They say California has four seasons: earthquake, fire, flood and mudslide. But you get up every day and it's a beautiful day. And birds are singing, and the sun is shining and it's not that cold. And it's gorgeous. If you want to be cold, you can drive to the mountains. And if you want to see the ocean, it's half an hour away. And nature is present. And I find that very, appealing. And art. And by that, I mean all types of the creative arts: music, paintings, photography, theater, television and movies, I find genuinely thrilling and renewing. And food. I love food. I'm a good cook. I like to cook, and I love eating out.

What advice would you give your younger self?
I would give my younger self the same advice that I would give a young woman entering my field today. And that is really not to confuse wanting to do what someone's doing with wanting to sleep with them, even though it's gotten me where I am today, wherever that is.

When I was young, I wanted to be Robin Hood. I didn't want to be Maid Marian. But as a girl, sometimes the only way that you could be in Sherwood Forest was to be Maid Marian. And I would try to avoid that situation now.

What advice would you give a young woman entering your field?
I think it's more possible to avoid those situations, because I think from my generation and even for generations after me, that was how you got to do things. You hung out with people who did them. And that's the advice I would give, don't get confused between wanting to be someone and wanting to sleep with them.

MY WORDS; MY VOICE

Dear Reader:

Over the course of my lifetime, some people have accused me of being negative. I don't think I am negative; I think I am realistic. If you can see the train coming down the track before other people do, you have a better chance of not being run over by it. But in fact, I believe in the power of yes. I think you should say yes to life, yes to all the opportunities you are offered, yes to every new experience, yes to the adventure lurking just around the corner.

My mother always said, "Go to every party, you never know who you might meet." I no longer have to go to every party, but I've been to a lot of parties and met a lot of people, both friends and lovers, and I'm glad I did. Another friend of mine once said, "Have you ever said to yourself, gee, I wish I hadn't gone on that vacation?" Of course not. Have some of the yesses led down roads that ended in no? Of course, they have. But sorry not sorry, I'm glad I followed those roads.

As Patrick Dennis' Auntie Mame famously said, "Life is a banquet and most poor bastards are starving to death." So, chow down, eat up, partake of the movable feast that makes up life's various and glorious bounty. Say yes! To quote Henry James (who perhaps did not entirely follow his own advice) whether life is a banquet or a cabaret, or even a tale told by an idiot, signifying nothing: "Live all you can, it's a mistake not to."

X is for
-ray Technologist

Bridgette Waters

Bridgette Waters is an X-ray Technologist with a specialty in mammography, as well as bone density where she performs DEXA scans on patients to detect osteoporosis. Bridgette has worked in the field of radiology for over 15 years. She was previously a flight attendant for a major airline. She is a single mother to three beautiful children and enjoys spending her free time with them.

Bridgette is as sweet as she is beautiful. She is a consummate professional. I am delighted she agreed to share her journey.

Here are her answers to the questions:

Where were you born?
Big Bear, California.

How would you describe your childhood environment?
My childhood environment was very loving. My brother and I were raised by my mother. My father is a mechanical engineer and after the Gulf War he took a job in Saudi Arabia. My father enjoyed the money and liked being able to support his family. He just kept renewing his contract. He has never returned to the United States permanently. I grew up having one parent (my mother) who took care of me and my brother.

As a child, what did you hope to be when you grew up?
A model.

Did you know as a child that you would be engaged in your chosen work?
No.

Would you like to acknowledge one or more individuals who helped you shape your behavior, beliefs and work habits while on your early journey?
Jilayne Stephens Binning was like a mother to me as a young child. Jennifer Moore and Myrna Sobrino were dear friends from work and

Maureen Nowak, a dear church friend, was my midwife and delivered my second son.

As a young girl what difficulties did you have to overcome to move towards your dreams?
My father was not around much. He worked overseas. He would come home or meet us somewhere for vacation for two weeks at time twice yearly. We always had a great time but I would cry everyday of it knowing it was one less day together. The last time I physically saw him or heard his voice was when I was fifteen. After that, the only form of communication he would have with us was through email. It is a very sad story with no closure for any of us.

Where were you educated/trained for your work?
Keiser University, Lakeland, Florida.

How much training did your work require?
Two years of school in radiologic technology.

Once you entered the workplace, as a young woman, what obstacles did you have to overcome?
Learning to deal with different personalities from radiologists as well as co-workers and staff.

As a woman, what challenges did you have to overcome?
Sexual harassment in the workplace. Learning to balance my career with my family life.

Are you satisfied with your chosen profession?
Very much so! I love every minute of it.

Describe a typical work-day from morning 'till night.
I am up early, get the boys ready for school, feed them and make sure they get on the bus. Then I get ready for work while entertaining the baby. I make sure to get a cup of coffee in me before I do DEXA scans until noon, interact with patients and complete the paperwork for each patient. I walk two miles on my lunch break and start all over again when I return. When I get home, we do homework first. Then dinner, baths, and bed. I also do a thirty minute workout in between all of that chaos, lol.

Are you preparing for a different career?
Not currently.

Have you continued your studies?
Yes. I keep up with the latest techniques available. Every year my
company sends me to the annual ISCD meetings (International Society
for Clinical Densitometry) whose mission is dedicated to advancing
high-quality musculoskeletal health assessments in the service of
superior patient care.

What are your current goals?
To become debt-free. To save money for my children's college
educations. To go further in my career.

Do you have a ten year plan?
Get my children through school.

Where do you see yourself living in ten years?
In the same area where I am now.

Do you have a twenty year plan?
To pay off my house.

Do you have a retirement plan?
Move to a tropical island and do nothing!

How do you spend your leisure time?
Traveling with family, dinner out in a nice restaurant, attending church.

What frightens you?
Losing a loved one.

What saddens you?
Cancer! Hearing stories of loss from my patients (spouse, child, relative
or friend).

What pleases you?
Making people smile. Being a mother to three beautiful children.
Spending time with my mother and children.

What advice would you give your younger self?
Never be afraid to go after your dreams. Life is short!! Make it count!

What advice would you give a young woman entering your field?
Never be afraid to stand up for what is right. Take care of you because no one else will.

MY WORDS; MY VOICE
My mother raised my brother and I by herself with dignity and grace. She was fortunate enough to get financial support from my father. However, watching her depend on him for that money taught her and I a lot! She always told me to never depend on a man. She taught me how to be an independent woman. She is the inspiration behind my drive to work hard. I am humbled and grateful for her advice!

\mathcal{Y} is for
oga Teacher

Frances Miller

Frances (Fran) Miller has been teaching Yoga for over fifty years. At ninety-eight years old, she holds 90 minute classes three times per week.

Fran is a highly energetic woman eager to see projects completed (she was one of the first women to join me on this venture.) She is charming, joyful and fully engaged in life.

I was introduced to Fran by a mutual friend and immediately taken with her creativity, sense of joy and optimistic outlook on life which she has propitiously passed onto her two successful and devoted daughters.

Here are her answers to the questions:

Where were you born?
New York.

How would you describe your childhood environment?
Well taken care of by my loving parents and my great older brother. My dad was a grocer, my mother had been a doctor in Russia but when she came to America, the only jobs she could get were as a nurse.

As a child, what did you hope to be when you grew up?
At different times in my life, I wanted to be a nurse, a schoolteacher, a kinesiologist, an archeologist and a journalist.

Did you know as a child that you would be engaged in your chosen work?
No.

Would you like to acknowledge one or more individuals who helped you shape your behavior, beliefs and work habits while on your early journey?
Besides my family, Rabbi Joel DeKoven, my guru and yoga teacher, the rabbi that stood on his head had indeed a very big and good influence on my life. Rabbi DeKoven had been a certified yoga teacher by the famous Indra Devi the first woman yoga teacher, known as The First

Lady of Yoga.

As a young girl what difficulties did you have to overcome to move towards your dreams?
None, really.

Where were you educated/trained for your work?
Los Angeles, California. Many years before yoga became popular, it caught my interest. It held a certain fascination for me, but at the time it seemed so far out. Around 1965, I saw an ad in the paper where a rabbi was teaching Hatha Yoga classes at the Y in Van Nuys, California. How could I pass that up? I started taking classes regularly and took to it like a duck to water!

Other classes started popping up, so I decided to try different instructors, but I always returned to Rabbi DeKoven's class. His method appealed to me the most. The final time I returned to his class, he asked if I would demonstrate for him and in turn, he would give me classes for free. How could I miss?

How much training did your work require?
Taking classes from the rabbi naturally led me to teaching Hatha Yoga with his encouragement. The on the job training was on-going. One day he told me he was unable to teach a class in Studio City and asked if I would fill in for him. My reply, "Oh no! I couldn't teach." He in turn said it would be a mitzvah, basically a big favor to him. How does one refuse a rabbi when he asks you to do a mitzvah? (Traditionally a mitzvah means a commandment – in today's vernacular, it is used as a worthy deed.)

So on that particular day with butterflies in my stomach and with a list of notes I made up for myself, I appeared at the Studio City class and somehow, I think with an angel looking over me, I started to teach without even once referring to the notes I had made.

From time to time my guru asked me to fill in for him at either of the Y's in Van Nuys, Beverly Hills, Studio City or at his synagogue in Sherman Oaks. Students seemed to like the way I taught and offered me private jobs for groups in their homes.

One day Rabbi DeKoven invited me to lunch and informed me that he was thinking of retiring and moving to Israel and if anyone deserved his class it would be me. Around that time, I received my certification.

I began teaching Yoga for five to six summers, five days a week at Highland Springs Resort. I would teach late afternoons on a beautiful lawn surrounded by pine trees. Guests would either participate or watch.

Once you entered the workplace, as a young woman, what obstacles did you have to overcome?
None, really except for the butterflies in my stomach at first.

As a woman, what challenges did you have to overcome?
With regard to my work, none, really. I was widowed early and had to raise my two daughters on my own.

Are you satisfied with your chosen profession?
Yes, as I've been teaching yoga for over fifty years. One evening at the Highland Springs Resort a well-dressed lady approached me and mentioned she had been observing me teaching the yoga class. She said, "There are a lot of yoga teachers out there but that besides being a good one, I was a born yoga teacher." That blew my mind. And when this stranger introduced herself it took my breath away. She was a well-known European yoga instructor who had a studio in Beverly Hills. She invited me to attend her studio after my summer job ended. I accepted her offer, attended classes for awhile after which she offered me a teaching job. Unfortunately, the timing didn't work out for me, but it was quite flattering.

I continued teaching and my students have stuck with me, unless they have moved out of the area…and some still keep in touch.

Describe a typical work-day from morning 'till night
I teach three times per week (one and half hour classes); two evening classes and one morning class. Additionally, I teach private classes upon request.

Are you preparing for a different career?
No.

Have you continued your studies?
Yes, by reading articles about yoga.

What are your current goals?
At ninety-eight years young–to teach as long as possible.

Do you have a ten year plan?
Yes, keep moving!

Where do you see yourself living in ten years?
Right where I am in Southern California.

Do you have a twenty year plan?
When I turn 118, I'll let you know.

Do you have a retirement plan?
Yes. Keep on moving!

How do you spend your leisure time?
I've traveled extensively through Europe, Asia, Africa and Israel, as well as within the United States.

I've taken a hot-air balloon ride and went parasailing, both exhilarating and fun.

To name just a few of my activities; I take creative writing classes, musical instrument recorder classes and acupressure classes. I attend lectures, movies, concerts, plays, the ballet, storytelling salon and I play Mah Jongg.

(Occasionally, I take naps – ha ha ha.) My daughters call me the "Ever Ready Bunny."

What frightens you?
People driving crazy. Rent prices going up.

What saddens you?
Losing a friend.

What pleases you?
Visiting with my daughters.

What advice would you give your younger self?
Follow your heart.

What advice would you give a young woman entering your field?
Not just to instruct. You should correct, as well – and tell your students
to listen to their bodies.

MY WORDS; MY VOICE
Along with answering your wonderful questionnaire, Bev, I've
included a little wisdom. If life isn't going right, turn left.

Z is for Zamboni Driver

Tracy Lee Moller

Tracy Moller (known affectionately as Timmy) is rare among Zamboni Drivers. Why? Because most of them are men. The Zamboni machine, invented by Frank Zamboni in 1949 is basically an ice resurfacer used in ice rinks internationally to smooth the ice before skaters take the ice to either play hockey, perform in ice skating shows or practice for the Olympics and other events.

Tracy has worked at Iceworld Olympic Ice Rink, Brisbane, Australia for thirty years and holds the record for completing the fastest resurface of the ice; seven minutes.

She is passionate about her job and enjoys working at Iceworld. Many of her lifelong friends are those that she met through ice skating.

Tracy lives in the western suburbs of Brisbane and enjoys spending time with her Moodle (crossbred Maltese and Poodle), Coco Channel!

I reached out to a colleague in Australia who put me in touch with Tracy. She is kind, efficient and a pleasure to work with – and has an interesting story to tell.

Here are her answers to the questions:

Where were you born?
Brisbane, Australia, 1964.

How would you describe your childhood environment?
I grew up in Acacia Ridge close to where the rink was built and opened in 1979. I had a carefree upbringing and was one of four children; two brothers and a much younger sister. I was always a bit of a tomboy, enjoyed playing outdoors and spent lots of time with my grandfather out and about in his truck selling fruit and vegetables.

As a child, what did you hope to be when you grew up?
I still haven't grown up and love my job and driving the Zamboni! As a young teenager I always wanted to work with animals.

Did you know as a child that you would be engaged in your chosen work?

It wasn't till my late teens when I started hanging out at Iceworld Olympic Ice Rink Acacia Ridge that I gained a love of ice sports and like many patrons was mesmerized by the Zamboni. To this day the Zamboni is a favorite of many of our fans, especially young kids.

Would you like to acknowledge one or more individuals who helped you shape your behavior, beliefs and work habits while on your early journey?

There were two rink managers in-particular that certainly influenced my career path in the early years. Garry Stubbs who was the rink manager from the time the rink opened, and still works as a session manager at Iceworld Olympic Ice Rink Boondall. After Garry moved to Iceworld Olympic Ice Rink Boondall, Dell Whelan became the manager at Iceworld Olympic Ice Rink Acacia Ridge. Garry taught me how to drive the Zamboni. I pride myself on being a great Zamboni driver today, and have fortunately not followed in Garry's footsteps, given that he drove the Zamboni through the barrier on one of his first drives! Dell was a mentor and helped me to develop my management skills.

As a young girl what difficulties did you have to overcome to move towards your dreams?

As mentioned, I was always a bit of a tomboy growing up and I fitted in well at the rink and worked well with the rink team. I was lucky growing up that my parents were always very supportive and encouraged both me and my siblings to follow our dreams.

Where were you educated/trained for your work?

It's a pretty unique job and it's all on job experience and training.

How much training did your work require?

Learning to drive the Zamboni takes skill, however it generally takes only a few weeks to learn to drive and manage the Zamboni on the ice-surface. It also takes time to learn the other key aspects involved with being a good Zamboni Driver and cutting the ice well. These include:

- How much ice to cut off

- The amount of water to lay

- Mastering the correct ice pattern procedure

- And managing to do all of the above in a small window of fifteen minutes between sessions

Once you entered the workplace, as a young woman, what obstacles did you have to overcome?

While working part-time at Iceworld in the early days I was working full-time for a forklift spare parts company, which was predominantly male dominated. I started out as a spare parts picker and packer and quickly moved to a warehouse supervisor position and then onto purchasing. In the male-dominated industry, it was always challenging to prove I was as capable as my male colleagues of completing the task competently.

As a woman, what challenges did you have to overcome?

I had to learn to drive a forklift and it was certainly more challenging as a female to prove that I was capable of this aspect of the job. On many occasions while unloading trucks the "compliment" would be, "You're not bad for a woman!"

Are you satisfied with your chosen profession?

I love what I do, and I am very satisfied in my position as both a Zamboni Driver and Session Manager at Iceworld Olympic Ice Rink Acacia Ridge. It still gives me a thrill to this day when I drive the Zamboni out and young patrons are waving and cheering from the barrier. I take a lot of pride in providing an excellent quality of ice surface for the many customers that use our ice rink services from figure skaters and ice dancers to hockey players, speed skaters and the general public. I have made many life-long friends during my long career with Iceworld and enjoy every day.

For many years I resurfaced the rink prior to Australian Gold Medal Speed Skater, Steven Bradbury's training. Our rink is famously referred to as "The home of Steven Bradbury."

In more recent years, I was lucky enough to manage sessions and

resurface for Margot Robbie as she trained at our rink in the lead-up to her role in *I, Tonya*.

Describe a typical work-day from morning 'till night.
From arriving at the rink at 5:30 a.m. and opening up the rink, I do my first re-surface for early morning ice hockey training to moving on to:

- Setting up for figure sessions

- Skate school for our beginners

- Getting ready and managing our very busy public sessions

During all these sessions, I am resurfacing at various intervals through sessions and the day. On weekdays I have a later start and stay on to close the rink and ensure the ice-surface is left in good condition for the coming days. This can often be challenging given the hot Queensland climate.

Are you preparing for a different career?
No, I love what I do. I do enjoy passing on my skills as a Zamboni Driver to the next generation.

Have you continued your studies?
Like many people of my generation, I started in an era of paper processes. We are always upgrading to new technologies which I have embraced and adapted to over my thirty-year career.

What are your current goals?
My current goals are to instill a genuine love of ice sports and delivering a high quality of service to all our patrons and to all my staff. I would also like to pass on my skills as a great Zamboni Driver to the next generation of Ice Technicians.

Do you have a ten year plan?
To be fit and healthy enough to still be out there on the ice everyday doing what I love.

Where do you see yourself living in ten years?
I'm a Brisbane girl through and through.

Do you have a twenty year plan?
As above and importantly, still living life, maybe having grown up a little.

Do you have a retirement plan?

I guess I can't really see myself not having an involvement with the ice rink. It has certainly been more than just a job to me. Many people that I have met through my work have become lifelong friends and many are like family to me.

How do you spend your leisure time?

Sleeping! Going back to the rink and enjoying watching family and friends train, compete and forge careers at the rink and going on to becoming great coaches.

Iceworld really is a huge part of my life and so many amazing and treasured memories have been made at the rink. I am extremely lucky to be in a job that I truly love and that has provided so many rewards professionally and personally.

What frightens you?

Sliding towards the barrier and losing control of the Zamboni, I don't want to do a "Garry."

What saddens you?

I have seen lots of youngsters grow up on the ice, become great skaters in their chosen ice sport. It is always sad to see them retire. This often means that they move on and I miss seeing them on a daily basis.

What pleases you?

Looking back at the "perfect sheet of ice" after I have resurfaced and being complimented on it by the patrons.

What advice would you give your younger self?

Definitely chase your dreams, definitely do what you love, it will keep you young. And buy a good set of gloves, you are going to need them to keep your hands warm.

What advice would you give a young woman entering your field?

You can do it, persevere, sometimes you might have to work that little bit harder, but never let anyone tell you that you can't do it!

MY WORDS: MY VOICE

I'm happy to share the joy of ice skating events. Iceworld is a not for profit business governed by *Ice Skating Queensland* so its members benefit by getting cheaper ice hire. We host Birthday Parties, Learn to Skate Classes, Private Lessons, Ice Hockey, Synchronized Skating, Speed Skating or even find out about Curling. We've got it all here at Iceworld.

Acacia Ridge is forty years old and Boondall is twenty five years. That is a long time for ice rinks due to the hot climate in South East Queensland.

Check us out at anyone of our two locations,

Iceworld Acacia Ridge
1179 Beaudesert Road
Acacia Ridge

Or

Iceworld Boondall
2304 Sandgate Road
Boondall

LINKS:
www.iceworld.com.au

www.facebook.com/Iceworld-104805532916758/?ref=br_rs

Printed in Great Britain
by Amazon